TERMINAL STAGE

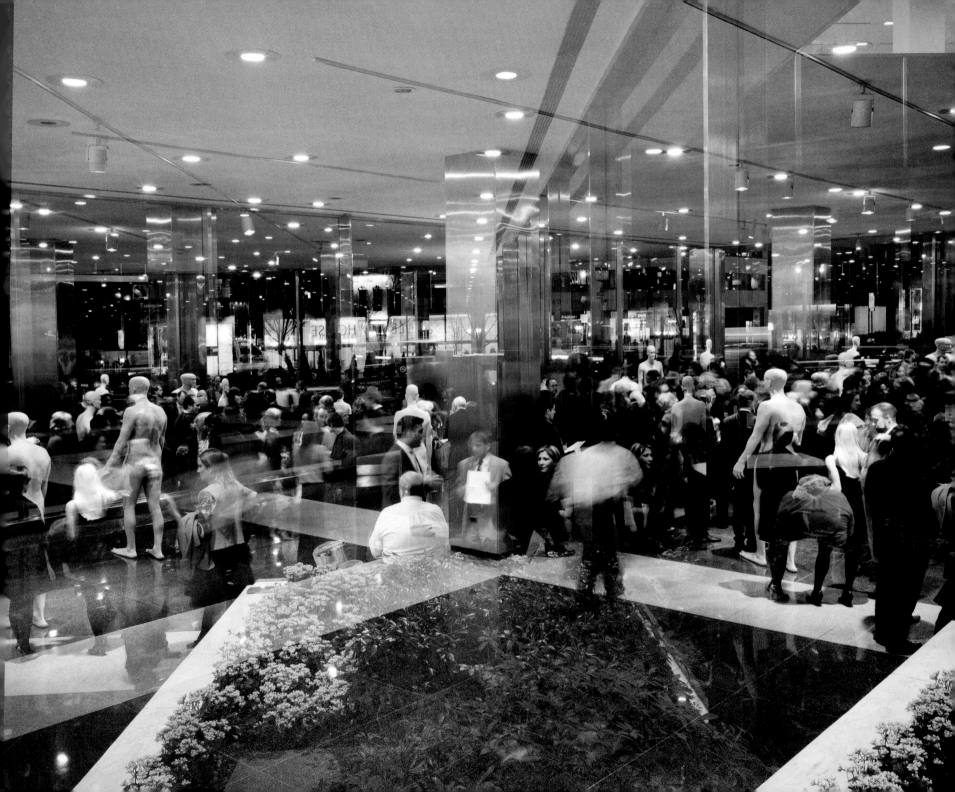

RICHARD DUPONT TERMINAL STAGE

CHARTA

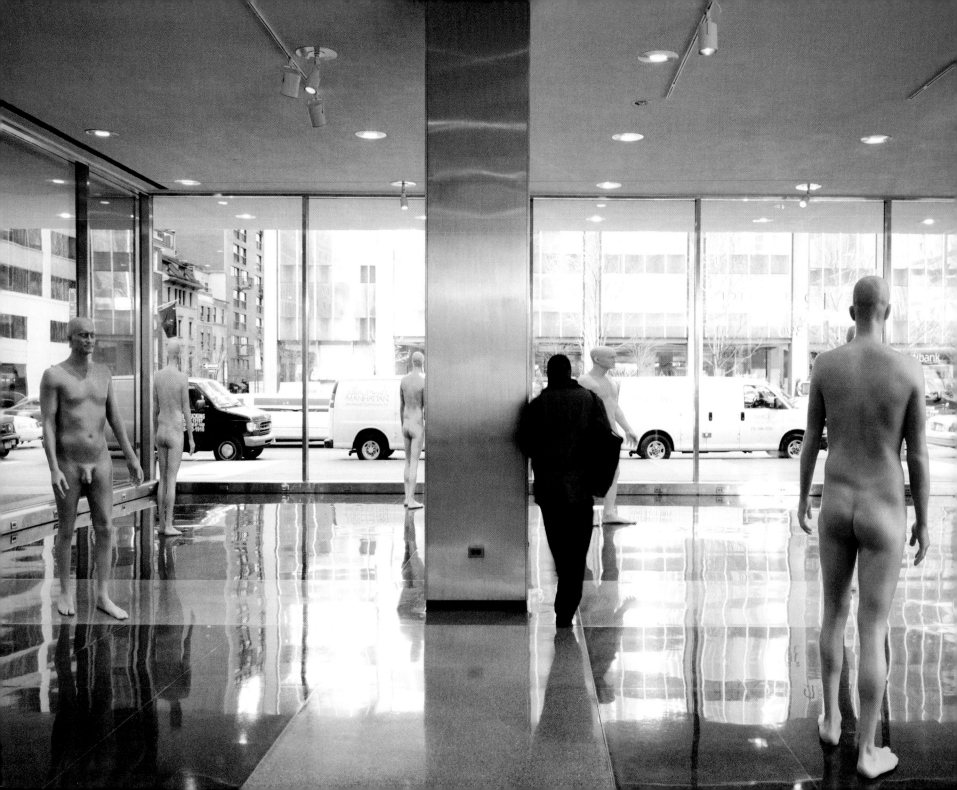

Contents

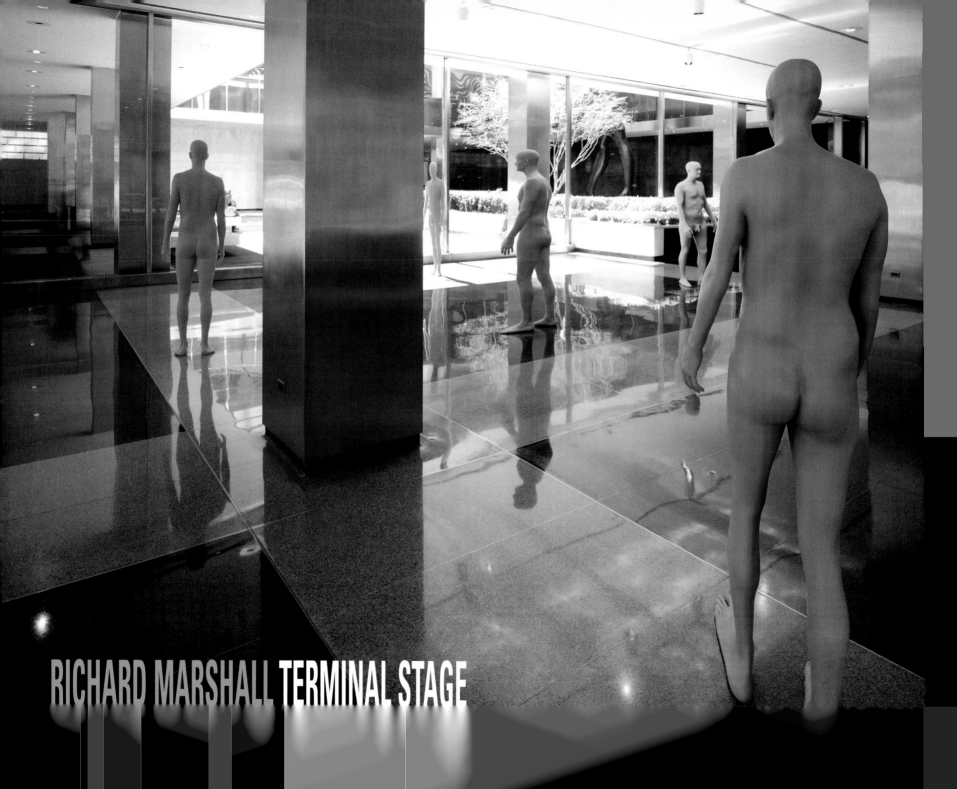

RICHARD MARSHALL TERMINAL STAGE

Richard Dupont is engaged in the centuries-long tradition of figurative sculpture. Using his own body as subject matter, he employs advanced technological devices and twenty-first-century materials to achieve realistic, although drastically manipulated, human figures. Dupont has created nine self-portraits that are laterally and horizontally manipulated so that they are radically distorted and can only be seen as an accurate, complete body from one vantage point.

Terminal Stage is intended as a public art piece. The involvement of the viewer is essential in the meaning of the piece. It was also conceived as a site-specific intervention. Lever House was the first modern structure built on the New York City grid, and it is a highly charged and symbolic site, emblematic of the revolutionary changes in architecture and urban space that have taken place over the half-century since its construction. The lobby space confounds traditional readings of "public" and "private" as well as "interior" and "exterior" space, and *Terminal Stage* emphasizes the instability of a single reading of the site. The lobby space is both a "terminal" and a "stage." The transparency of the site emphasizes and implicates the viewer, the passing pedestrians and the traffic that flows around the building.

Dupont's effective insertion of his own body into the vast depersonalized matrix of biometrics and industrial design began in 2004 with a full-body laser scan. To accomplish the body scan, Dupont traveled to a General Dynamics facility on Wright-Patterson Air Force Base, Ohio, and participated in a broad anthropometry study.

The examination involved extensive manual body measurement (traditional anthropometry) as well as a full-body laser scan. The data from such studies are sold to both the military and large clothing manufacturers who use the generic averages to design anything that interfaces with the body, such as ejection seats, flack jackets, blue jeans, socks. These systems and designs are concerned with averages and the standardization of the body.

Dupont, however, is not interested in average body types. Through the use of computer programming he is able to maneuver his real form into surreal shapes that are then converted into a three-dimensional model and cast in polyurethane resin. As Dupont states, "The work actually represents the 'anti–self portrait,' because the body image is reduced to numerical information and computerized polygons that are mechanically translated by the computer into forms, resulting in an object that exemplifies the monolithic force of the digital information age." His works are rooted in the tradition of those who have attempted to portray, in representational form, the visions that lie beyond rational perception. Dupont's work makes reference to the hallucinatory effects of technology, with its promise of transcendence and its equally potent destructive effects.

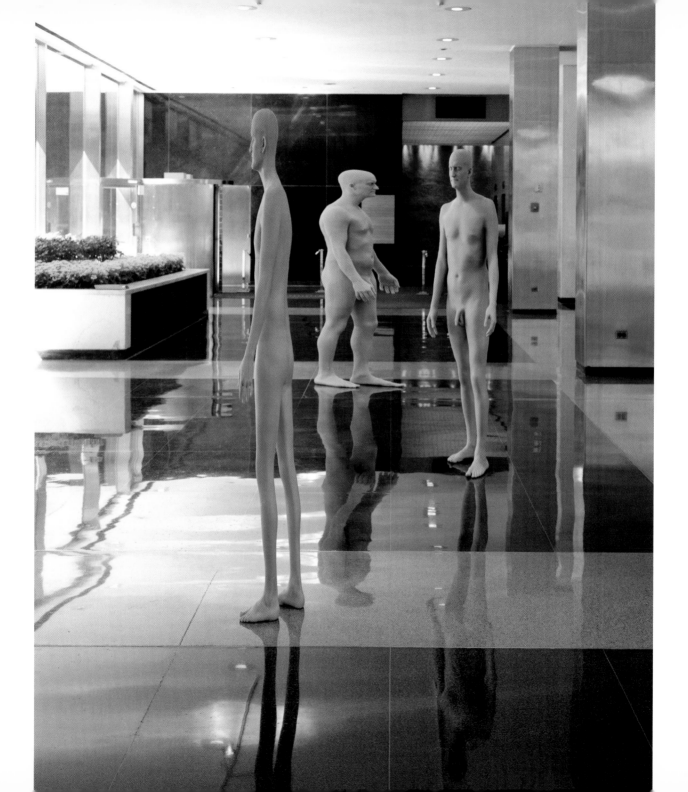

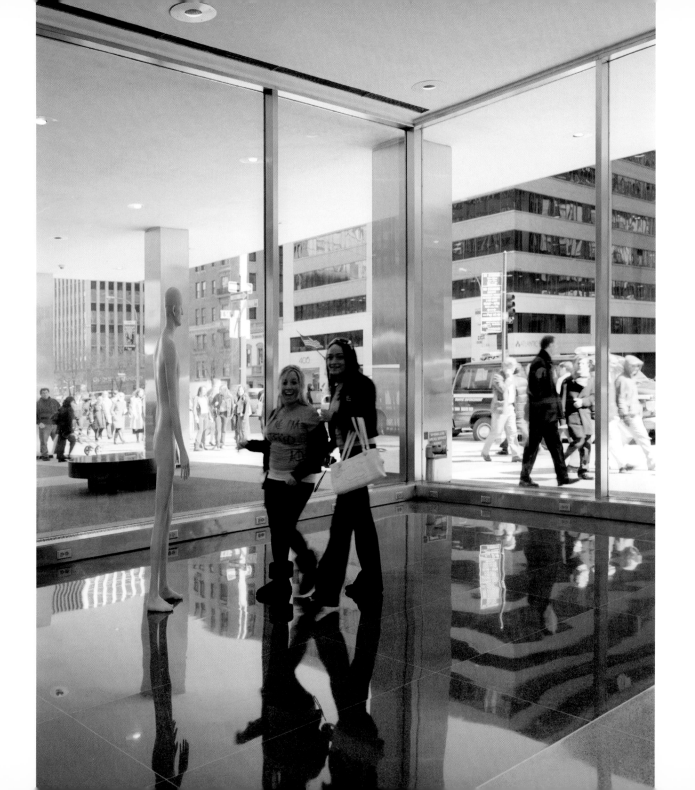

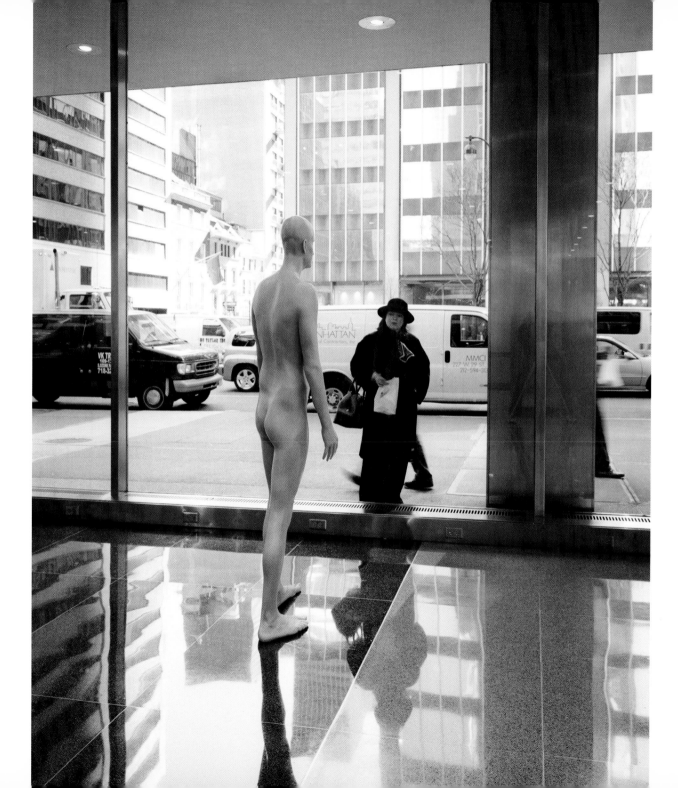

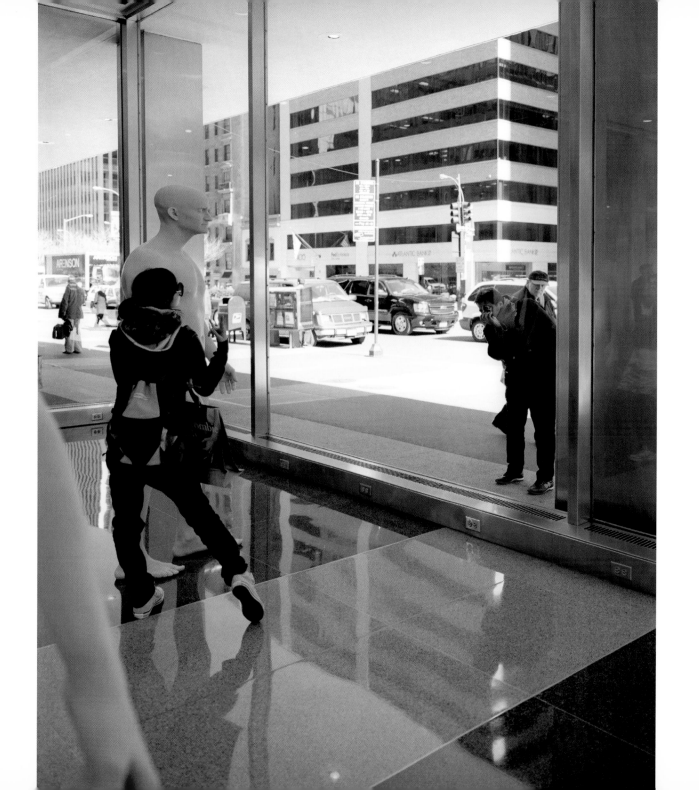

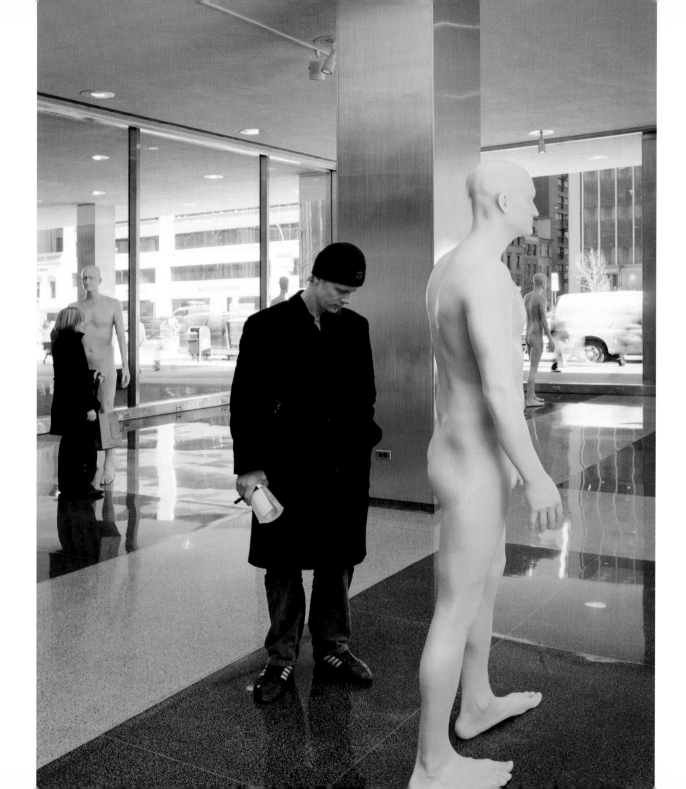

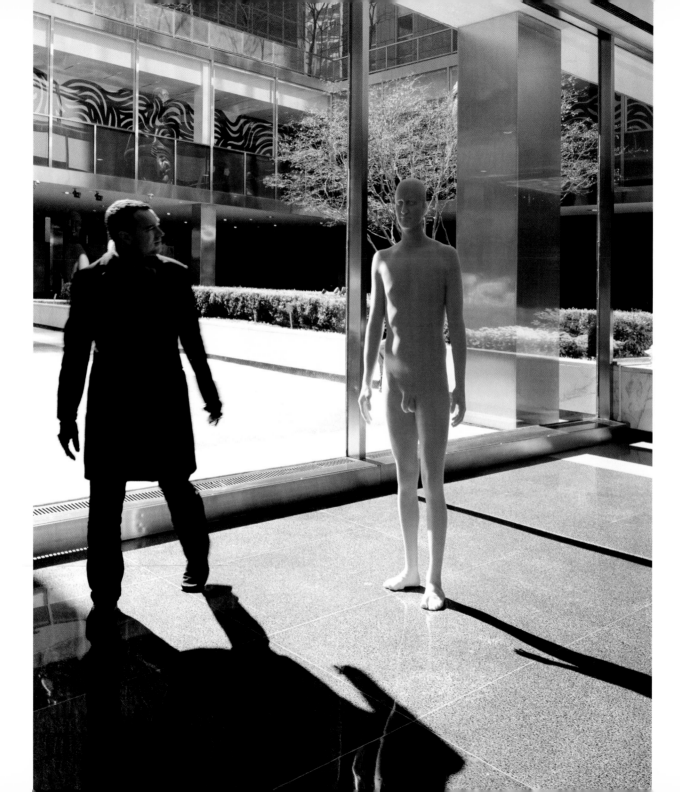

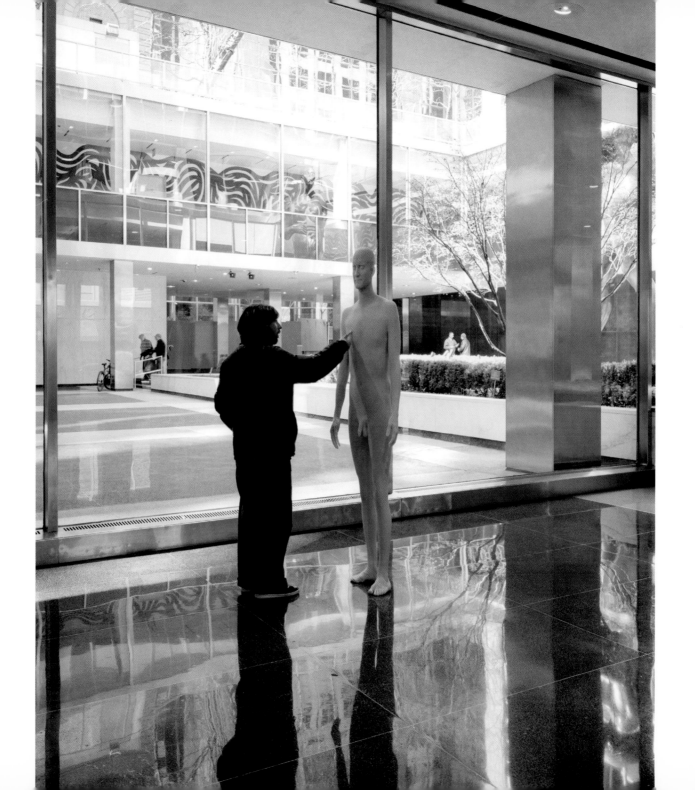

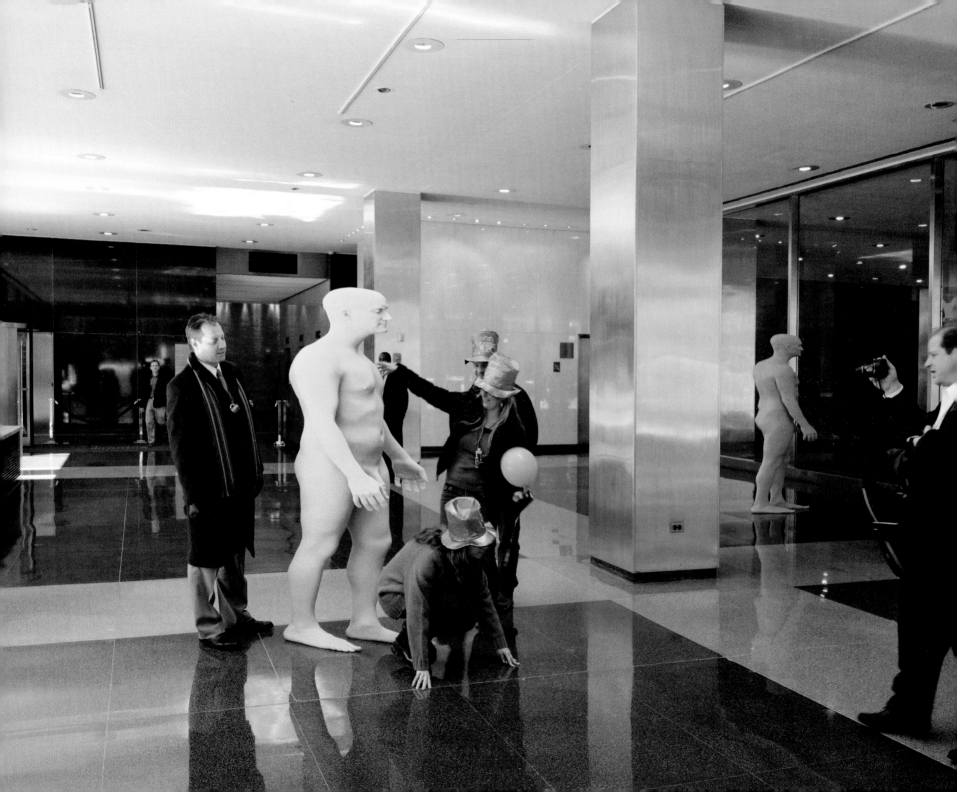

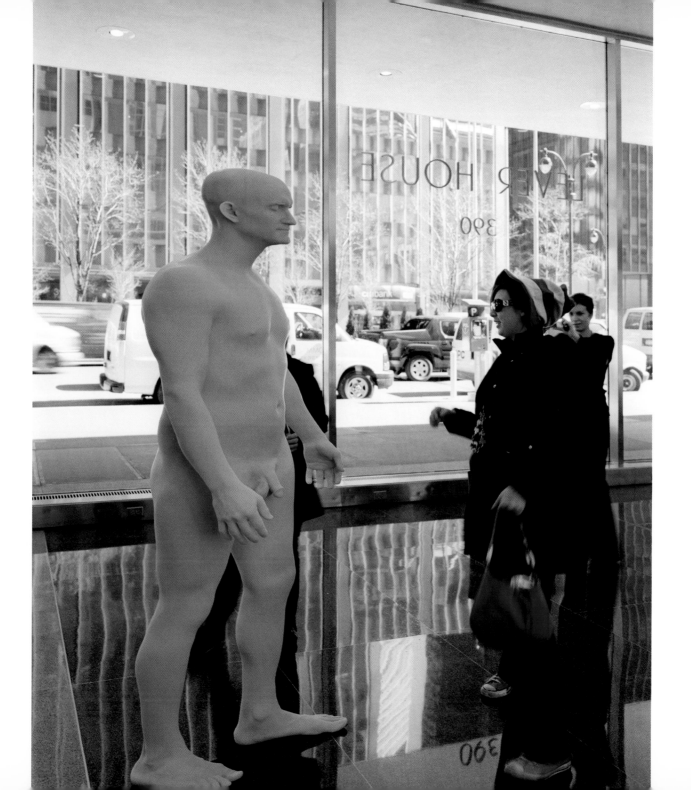

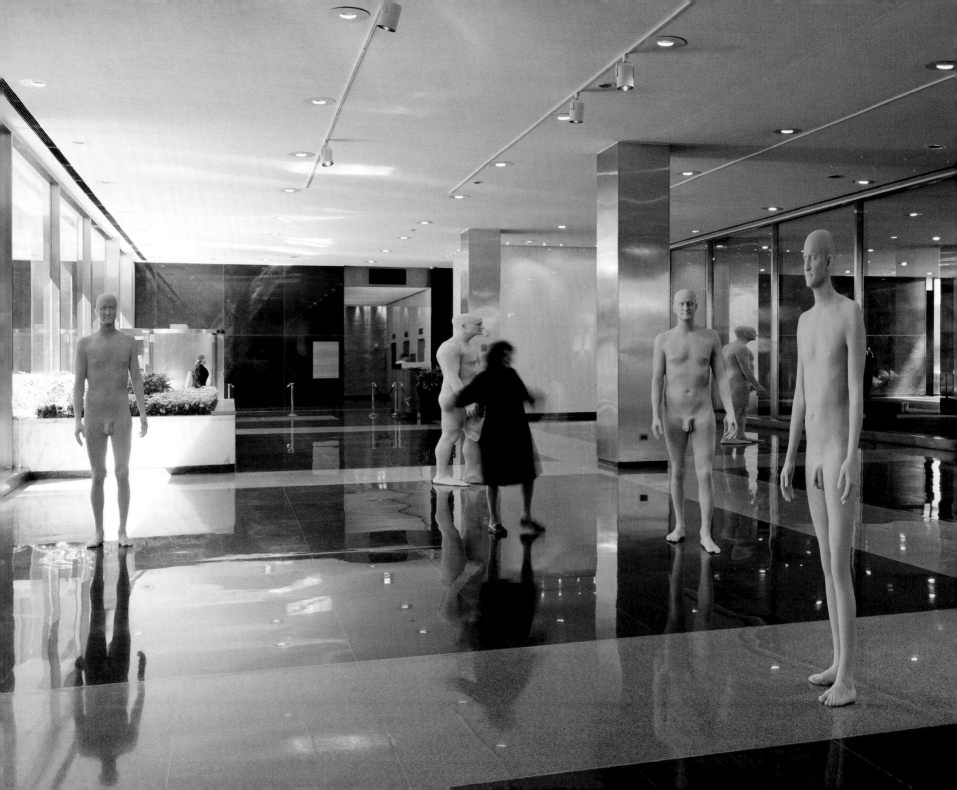

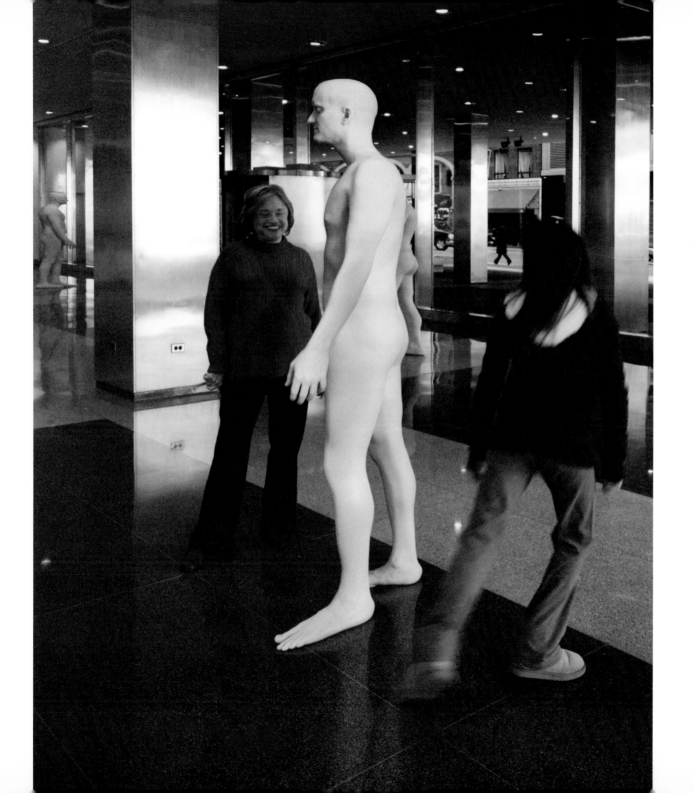

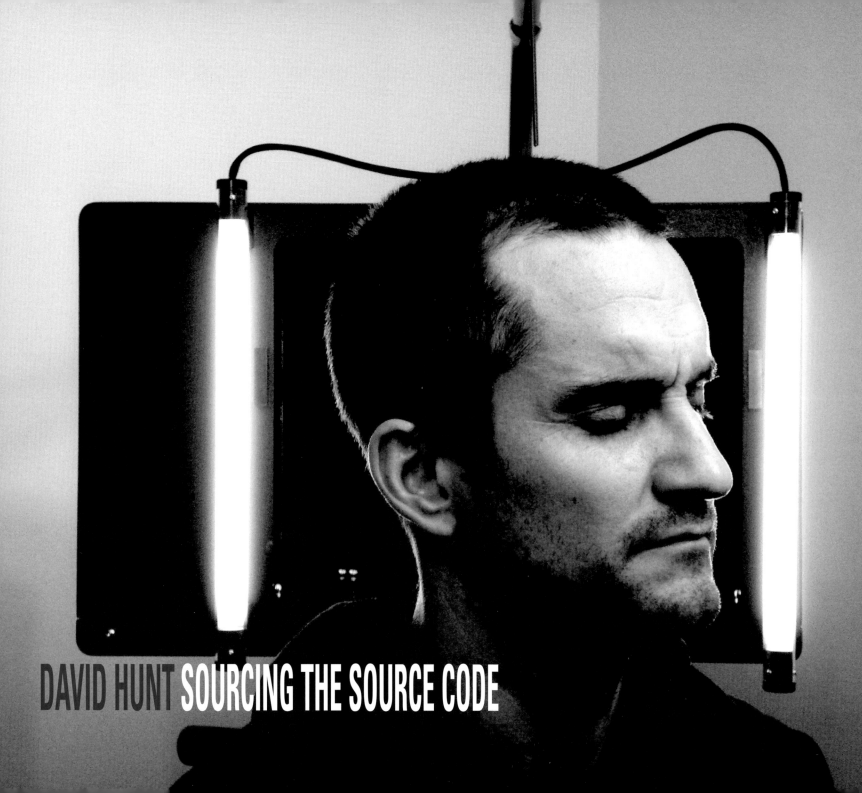

DAVID HUNT **SOURCING THE SOURCE CODE**

My intention is to tell of bodies
changed to different forms.
—Ovid

It's no secret that the Ancient Greeks were the first certifiable, full-fledged, dyed-in-the-wool obsessive-compulsives. One imagines them traipsing about the Acropolis in sandaled feet, slide rules poking out of pocket protectors sewn into the chests of their loose-fitting togas, one tremulous hand absently clutching a neatly bullet-pointed PowerPoint presentation incised on a waxen stone tablet, while nervously thumbing the latest CrackBerry-like abacus in the other. A not-so-funny thing suddenly happens on the way to the Forum, unheralded by celestial bugle or Imperial sundial alike: a panic-inducing solar eclipse spreads its darkening circle over the open-air amphitheater during *Electra*'s tragic third act. Does the scattering mob fetch the proverbial fattened cow and trot it out for sacrificial appeasement? Do they bow down in ritual supplication? Comb the burrs out of the nearest Golden Fleece? Not quite. Like sun-kissed Rain Men with fashionable bowl cuts mumbling "six minutes to Wapner" or "twenty-seven, definitely twenty-seven," they do what any civic-minded Athenian would in 500 B.C.: they look to the numbers.

The Greeks, to put it mildly, were no fans of inexplicable randomness, ambiguity or multiplicity— cosmic or otherwise. Abstractions of any kind, in the Hellenic imagination, were the greased skis down the slippery slope to out-and-out chaos, a palpable fear and trembling for a civilization still collecting itself after the turbulent break-up of the Mycenaean world. They were methodically inclined to impose the same strict mathematical protocols and rules of commensurability on the Parthenon as they were to parsing the component wavelengths in a pesky, scene-stealing band of mystical light. It seems hard for me to fathom that while staring through the pinholes of my own makeshift, foil-wrapped cardboard sunglasses— slack-jawed with giddy third-grade anticipation for my own first eclipse—2,500 years earlier the Greeks used astrolabes to dispatch this ambient wonder with the bureaucratic efficiency of a Boy Scout demonstrating how to flick on a flashlight. Back then, there wasn't a plague that Pythagoras couldn't handily dispatch with a compass and a protractor, a drought that couldn't be rationalized into acceptance by the metrical schemes of a cleverly worded pensée. *What's that you say? Xerxes is lashing the Hellespont 300 times with an army of Persians two million strong? Quick, summon the court sculptor to carve a few ideal kouros figures and restore public order.*

Back in 500 B.C., were an apparition of the shroud of Zeus to suddenly, enigmatically appear in your olive tapenade, you'd instantly grab your trusty ivory stylus and subject its shadowy, amorphous contours to the circle/square template of the Vitruvian Man long before you'd race up the cobblestoned streets of Athens to share the Good News with your fellow Athenians. In short, your first instinct in gridding out this Olympian augury would be a stone-cold empirical one, an attempt to ascertain in an earnest spirit of scientific inquiry some semblance of a corporeal essence hidden within the cloth's woven threads through a reductive process of ever-smaller internal proportions. With simple schematic drawings, then, you would be mathematically ghost-busting the ethereal specter from the more digitized poltergeist forever lodged in the machine. Your holy relic would now resemble an 8-bit shrine to this Poetics of Lego Modularity, a known and knowable sequence of units erased of any messy (and possibly vengeful) mystic potential. In a newly fragmented world where every numinous cloud was lined with weaponized silver thunderbolts, most Greeks found in this compulsion for mapping terrestrial phenomenon the kind of temporary psychic release otherwise reserved for the transcendent. Not for nothing, to judge from their hysteri-

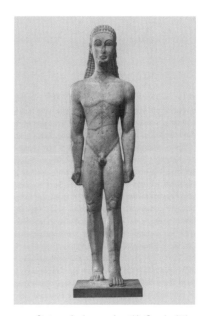

Statue of a kouros (youth), Greek, Attic,
Archaic, ca. 590–580 B.C.
Marble, Naxian
76 in (192.7 cm)
The Metropolitan Museum of Art, Fletcher
Fund, 1932 (32.11.1)
Image © The Metropolitan Museum of Art

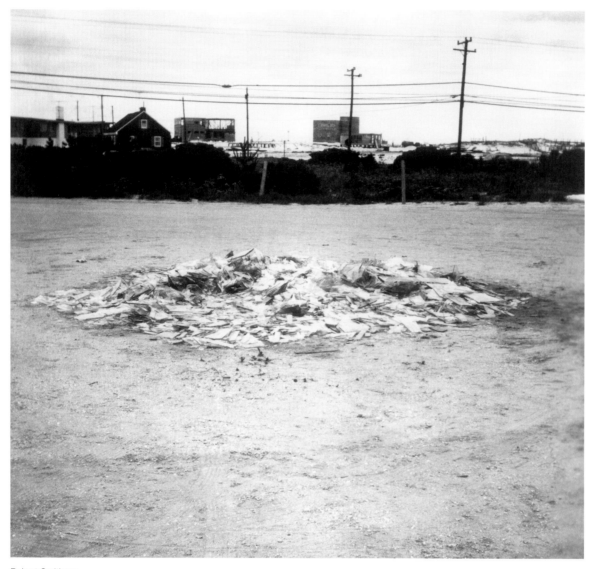

Robert Smithson
The Map of Glass (Atlantis), Loveladies Island, New Jersey, July 11-31, 1969
Broken glass, raw earth
Dimensions variable
Art © Estate of Robert Smithson / Licensed by VAGA, New York
Image courtesy James Cohan Gallery, New York

cally mechanized Erector Set world, did they coin the phrase *deus ex machina*.

But why stop at this fictional shroud of Zeus? When we look at the average kouros standing literally stone-faced in the Met, its extreme banality—even accounting for the era in which it was made—seems almost intentional. Though commissioned for votive or commemorative purposes, each ramrod spine, flat face, block head and slightly advancing left foot collectively suggest in their delirious anonymity the most nondescript of lifeless mannequins frozen in a vast geologic timescape. Caught up in his own feedback loop, nothing seems to penetrate the kouros's glacial reserve, nor does he invite the slightest transference with the viewer. That famous "archaic smile," precursor to the slyly arched lips that coat the *Mona Lisa* in its samsaric glow, is a kind of incipient ecstasy perpetually held in abeyance—a blissed-out perma-grin attending a cosmic joke with no earthbound punch line. Robert Smithson famously described this complementary nexus between the galactic and the prehistoric as the Zero-Zone: "Space Age and Stone Age attitudes overlap to form the Zero-Zone, wherein the spaceman meets the brontosaurus in a Jurassic swamp on Mars."

Though icily totemic in a primordial Stonehenge fashion, today we can't help but view the kouros as the generalized symbol of "arete," a synthesis of moral and physical beauty tidily wrapped in a package of generic nobility, intended by their original craftsmen. And "craftsmen," here, is the operative word. Not to bust the lantern-jawed chops of the Greeks, but a gratefully employed

class of sweat-stained proletarians in Ionic-collonaded barracks were feverishly hewing marble in the equivalent of state-sanctioned assembly lines, fashioning figurative versions of the Ten Commandments for an agrarian population in desperate need of an ethical code. Think about this for a moment. Before one commences the toppling of fashionable idols, it doubtless helps to have an idol. And similarly, a language of familiar icons would have to be in play before the first disgruntled iconoclast can even begin to conceive of shattering them. In other words, artisans, then as now, dutifully made commemorative artifacts with an emphasis on that word's blunt, unmediated facticity. Their attitude was blue-collar utilitarian, amateur anthropological. Gather enough artifacts, the lisping voice of Joseph Campbell reminds us, and you begin to approximate (and make sense of) the humble beginnings of a single, unified world.

An artist of the past fifty years, however—or at least the quixotic endangered species that is Richard Dupont—first selects from a pre-existing smorgasbord of available worlds that resembles, in its encyclopedia of options, a Chinese take-out menu, and only *then* does he activate the visionary dismantling. *This* attitude, by contrast, is professional time-traveling semionaut: a nimble voyager self-propelled into the fourth dimension, unyoked from linear, Hegelian periodization, who takes his aesthetic cues from the extreme past, the extreme future, and—when he's really cruising—everything in between. Free, in other words, upon climactic splashdown following these temporal border crossings, from the burden of logical, sequential revelation.

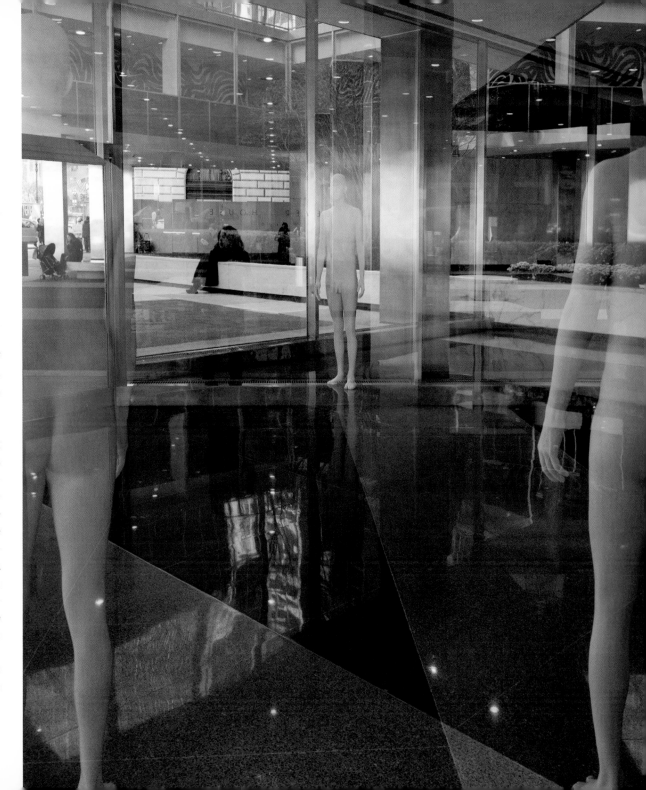

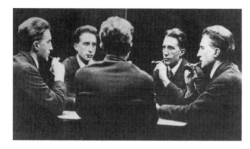

Marcel Duchamp
Autour d'une Table, 1917
Photograph
© Artists Rights Society (ARS), New York / ADAGP, Paris /
Succession Marcel Duchamp

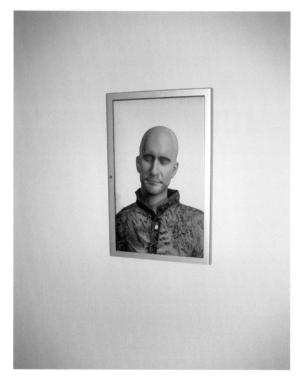

Forced to Stand, 2005
Digital animation
8 minutes, looped

Step into the mystic of this Lawrencian desert of no-time, however, and you quickly begin to see through the wide-focus lens of your disembodied, orbiting mind's eye the almost paralyzing slowness of evolution, the tortoise-like creep from bud to bloom. Now pop the green *and* the red pill, and suddenly this vast unfolding of crystalline time starts to rupture your earthling sense of patience. You come to the realization, as Dupont has, that art-historical evolution, as it plays out in daily papers, monthly mags and biennial exhibitions, is marked by an endless succession of recapitulated styles—micro-trendlets lending an illusion of progress via ever more nuanced cosmetic variations inherent in their surfaces.

To borrow a classic rock staple of FM radio: "It's a feeling you get when you look to the west and your spirit is crying for leaving." Here, that dreary feeling—more a precognitive intuition, really—is melancholy exhaustion; the West, an all-encompassing metaphor for a landscape of built monuments yet to realize their fundamentally entropic state of ruin; the "crying for leaving," a plea to dispense with the imperceptible long troughs of biological evolution in favor of the short, dramatic bursts erupting sporadically along its peaks. Specialists call this tipping point "punctuated equilibria," but if we project into the realm of aesthetics, such conceptual phase transitions are better understood by what our own Delphic oracle, Marcel Duchamp, in explaining the eight-year delay between ideation and completion of *The Large Glass*, termed "ultra-rapid exposure." Stare long enough at an object and the shadows it throws begin to become presences. Stare longer still, and those spectral presences harden

into tangible reality. Keep staring, and tangible reality returns to its disembodied shadow. And so on, ad infinitum, until the resulting ouroboros itself becomes the material substrate of one's work. Like Duchamp, this is the revelation that Dupont seeks to deliver in his sculpture.

• • •

I'm beginning to think that the sheer process of being taken apart atom by atom and put back together again is somehow purifying. I think it's going to allow me to realize the personal potential I've been neglecting all these years. I will say now, however subjectively, that human teleportation— molecular decimation, breakdown and reformation—is inherently purging. It makes a man a king!
—Jeff Goldblum as Seth Brundle in David Cronenberg's *The Fly*, 1986

I had been warned about Richard Dupont's studio. Various friends who held my welfare in high regard spoke in hushed, cautionary tones about a small army of replicants—possibly undomesticated, possibly feral—in shades of fetal pink. Certain occult rituals involving the digitizing of Dupont's naked body into a kind of liquid anima were alluded to. It was said that an array of medieval-looking steel calipers dangled from meat hooks suspended from the rafters, while large vats of epoxy resin nearly bubbled over onto the floor. Word on the street was that Dupont had imported some kind of gigantic soul-sucking scanner thingie that precisely captured a 3-D photo of one's entire body, but with

the unfortunate side-effect of rendering said guinea pig totally amnesiac and permanently somnambulant, destined to aimlessly paw and lurch its way along the dirty boulevard. Sort of like Margot Kidder in her methamphetamine psychosis phase playing Helen Keller, if Helen Keller actually resembled a very tired, faintly translucent, seven-foot-tall hood ornament.

Some even went so far as to allege that Dupont himself had recently suffered a serious accident and was now holed up in his studio rebuilding his shattered body with titanium-alloy knee joints, cochlear implants, penile prostheses, pacemakers and vascular stents, essentially borging himself into a better, stronger, faster version of his previously average, weaker, slower self. So yeah, naturally I was a little bit concerned. The whole Roy Batty shipwrecked on *The Island of Dr. Moreau* vibe started to crank my imagination into overdrive, redline my adrenal glands. I pictured a crew of Quasimodo-types with terminal scoliosis hunched over humming vacuum tubes and crackling electrodes. I pictured the sepulchral lobby of Alcor Life Extension in Scottsdale, Arizona, with the cryogenically frozen head of Ted Williams ensconced in a glass trophy case, liquid nitrogen seeping out of the panes. I heard the breathless words of Kyle Reese, back from the future to warn Sarah Connor, now back again to warn *me*: "That Terminator is out there! He can't be bargained with. He can't be reasoned with. He doesn't feel pity, or remorse, or fear. And he absolutely will not stop, ever, until you are dead!" As I rang the bell of his Lower Manhattan studio I half expected some Caucafarian droid assistant coated in mechanomorphic tribal tattoos to answer the vac-uum-sealed cargo hatch; a tip-to-toe illustrated man in tattered sackcloth and fur boots, lifting the visor on his VR goggles to greet me. But wait a second. Was that the ubiquitous '90s drum & bass sample of Spock intoning "pure energy" I heard dopplering off in the distance? Uh, no.

Dupont's studio, as it happens, is about as decidedly low-tech as the average custom body shop,

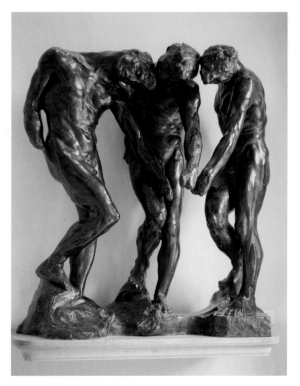

Bruce Nauman
My Last Name Exaggerated Fourteen Times Vertically, 1967
Neon tubing with clear glass tubing suspension frame
63 x 33 x 2 in (160 x 83.8 x 5.1 cm)
Panza Collection
Courtesy Sperone Westwater, New York
© 2008 Bruce Nauman / Artists Rights Society (ARS), New York

littered as it is with the tools of the typical figurative sculptor's trade—discarded plaster molds, power sanders and various chisels and picks that would have been right at home in Michelangelo's atelier as he hacked away at the Duccio stone. More a *Pimp My Ride* of nineteenth-century realistic statuary than the grisly *Face/Off* sequence that happens to poor, strapped-down Maria in Fritz Lang's *Metropolis* when a crude metal

Auguste Rodin
The Three Shades, 1902–04
Bronze
Musee Rodin, Paris
© Vanni / Art Resource, New York

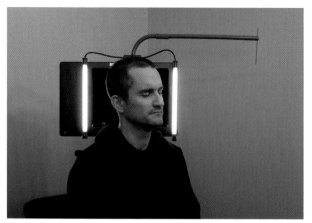

Richard Dupont undergoing
a laser scan of the head

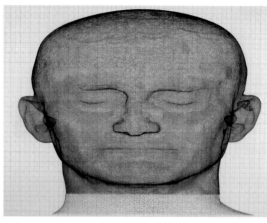

Untitled, 2007
Inkjet and collage on vellum
29 x 43 in

clanger-bot is overlaid on her panicked, Teutonic visage. As an assistant in a clinical surgeon's mask unscrewed the outer shell of a pocked and abraded mold to reveal the soft pink "flesh" within, it became increasingly clear that—cosmetically at least—Dupont's practice was grounded in a Classical mode; a chance to glimpse jaundiced brains floating in formaldehyde baths or the suspended cocoons in Michael Crichton's *Coma* was, quite thankfully, not forthcoming.

Dupont, too, was no mad Victor Frankenstein in a white lab coat, flicking circuit breakers on as electrical sparks fly around the dead, patchwork flesh of his beloved collage of human body parts. He was, instead, an affable, good-natured conceptualist more at home discussing personal touchstones such as Chris Burden and Bruce Nauman than the images of a cyberbolic carnivalesque—of transhuman Cat People with surgically altered feline eyes or Survival Research Laboratories' remote-controlled meat-puppets. Dupont is well aware (and well defended against) the kind of cinematic fever dreams that saturate the popular imagination, returning like the repressed steel nightmare of a gleaming T-800, which inevitably color the fantasy world of viewers who encounter digitally inflected humanoids conjured from today's massively powerful ecstatic technologies. His studio is reassuringly bereft of the pickled lobstrosities and assorted crustacean kitsch one sees in dystopian middle-future epics like *City of Lost Children*, because Dupont is that rarest of new-jack breeds, a conceptualist with a computer. That is to say, the bulk of the heavy intellectual maneuvering literally happens "off screen."

As we settled in, I mentioned to Dupont that the Italian tech firm HAL9000 recently spent nine hours shooting Da Vinci's *Last Supper* using a robot-controlled Nikon D2X digital camera to generate 1,677 distinct pieces of the mural at 12 million pixels each. I had read in the *Times* that the engineers subsequently stitched these samples together—quiltlike—to a total resolution of 16 billion pixels, said to be the highest resolution photograph in the world. Dupont smiled, right at home in a world of hyper-accurate, super-specific algorithmic alchemy.

He told me about his trip to the Wright-Patterson Air Force Base in Ohio, where he underwent a full-body laser scan—a scan that is generally used in the production of body armor, ejection seats and helmets. For Dupont's purposes this digital template—an almost absurdly detailed topographical map of his body—would comprise the source code for the group of surrogates he was sculpting. He described a vast, labyrinthine warren of bunker-like hangers, as nondescript as the average big box retailer, and the massive prefab Quonset hut where the scan itself took place fronted by a lone sign that read, somewhat ominously: "Human Effectiveness Directive." Once inside, the grand tour sounded like a capsule history of bio-military experimentation: stimuli deprivation tanks, pneumatic compression machines shooting ejection seats 100 feet in the air, and locked-and-loaded crash-test dummies wired with electrodes poised to meet their concrete makers.

Because it was a military base, though, and because Dupont is a civilian (an artist no less!) he had to agree to submit to a broad anthropometry study. He grew more animated as he explained: "They also sell the data created from these 3-D body scans to clothing companies like The Gap for use in sizing. And this was interesting because

a lot of my work plays into the idea of anthropometry or biometrics—identification based on retina or fingerprints or DNA or just the body."

But Dupont wasn't satisfied with the raw data accumulated from this one body scan. He further used a scanner resembling a miniature tanning bed for the face, and a third, smaller commercial studio scanner to "trap" his hands, feet and genitals. With this disembodied, ethereal information he began to make plaster molds of his extremities and then re-scanned those to achieve an even higher degree of resolution. As he pieced together this biological puzzle, he found at the end that the entire "meat-machine," as they say in compuslang, achieved a clarity of over two million polygons, or, as I thought to myself, a kind of atomized surface depiction intimating the microscopic, cellular logic teeming deep within his biological goo.

These discrete triangular units are familiar to anyone who has watched shows like *CSI*, specifically those obligatory scenes in which the geeked-out forensic pathologist computer-maps an alleged perp's facial features onto a green wireframe mannequin head, selecting from a whirling slot machine of archetypes as the skeletal dummy rotates in screen space. And like *CSI*, Dupont dumps this hyper-detailed mass of blank information back into a CAD program where it can be distorted, manipulated, stretched along any axes and generally morphed like molten taffy, while still retaining a faint but nevertheless mathematical relationship to the original. Finally, he uses stereolithography or "rapid prototyping," which squirts streams of epoxy in ever-widening concentric bands so that a synthetic replica is built up from

the 3-D computer file. This successive oscillation between flat, attenuated computer code and its externalized plastic replica—between a database of bloodless ones and zeros camped out in a virtual purgatory and the inert, malleable host awaiting corporeal animation—is not only the physical, but also the conceptual axis around which all of Dupont's sculpture pivots. What Burroughs described from his own junk-induced glacial remove as the "Thermodynamic Pain and Energy Bank," or, more concretely, the human body as a kind of automated teller that deposits and withdraws an existential currency of both psychic and physical essences (yet always tending toward entropic dissipation, toward exhaustion, toward bankruptcy), is the salient reason why Dupont goes to such ridiculous lengths to achieve what on its surface appears to be a photorealistic, albeit axially warped, full-figure self-portrait. Immanence or becoming, and entropy or disintegration, is the ideological maypole around which each digitally-assisted clone dances.

Although the numbers themselves are as featureless and inscrutable as your average postcard sphinx, the sheer ease with which anyone can corral what is essentially a perfect electronic carbon copy of oneself speaks to the larger issue of what Dupont, in a somewhat sinister tone, describes as "the human animal moving into the twenty-first century in a compromised state of autonomy." The implication here being that what Dupont can easily glean from a quick, constitutionally legal body scan, the *Uniting and Strengthening America by Providing Appropriate Tools Required to Intercept and Obstruct Terrorism* (aka, the USA Patriot Act) can *illegally*

3-D model of body (detail). Digital rendering

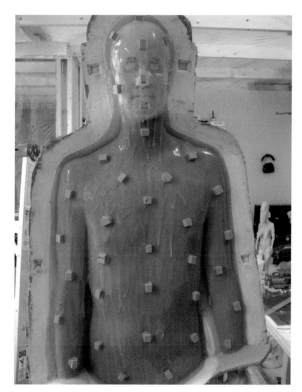

Moldmaking in process, 2007

NAME Richard Dupont DATE 11 / 1 / 04

Subj. No. _____

MALE X FEMALE ____

(Measurement Values in cm)

	Dimension	Value		Dimension	Value
1	Weight (Mass)	161.5			
			21	Thigh Circ. Max.	57.4
2	Stature	175.5			
			22	Ankle Circ.	26.8
3	Crotch Height	76.6			
			23	Foot Length 28.1	~~18.5~~
4	Thumb Tip Reach - 1	→			
	Thumb Tip Reach - 2	→	24	Shoulder (Bideltoid) Breadth	46.7
	Thumb Tip Reach - 3	→			
			25	Sitting Height	94.1
5	Subscapular Skinfold	11.0 mm			
			26	Eye Height Sitting	81.7
6	Triceps Skinfold	7.5 mm			
			27	Acromial Ht. Sitting	63.3
7	Arm Length (Spine-Shoulder)	20.3			
			28	Elbow Height, Sitting (Rt.)	25.1
8	Arm Length (Spine-Elbow)	54.5			
			29	Knee Height Sitting	54.2
9	Arm Length (Spine-Wrist)	84.3			
			30	Thigh Circ. Max Sitting	58.5
10	Armscye Circ (Scye Circ/Acrom.)	45.6			
			31	Hand Circ.	20.5
11	Chest Girth (Chest Circ at Scye)	94.8			
			32	Head Circ.	57.3
12	Bust/Chest Circ.	92.7			
			33	Head Length	20.1
13	Bust/Chest Circ. Under Bust	—			
			34	Bizygomatic Breadth	13.7
14	Waist Circ., Preferred	86.1			
			35	Head Breadth	15.6
15	Waist Height, Preferred (Rt)	98.8			
			36	Hip Breadth Sitting	36.5
16	Waist Front Length	46.7			
			37	Buttock-Knee Length	59.1
17	Total Crotch Length 66.7	~~73.0~~	38	Face Length	12.0
18	Vertical Trunk Circ.	173.0			
			39	Hand Length	20.0
19	Hip Circ., Maximum	98.2			
			40	Neck Base Circ.	44.8
20	Hip Circ., Maximum Ht.	88.1			

Measurer Mark _____

Recorder Cecelia _____

Jasper Johns
Target with Plaster Casts, 1955
Encaustic and collage on canvas with objects
51 x 44 in (129.5 x 111.8 cm)
Art © Jasper Johns / Licensed by VAGA, New York

List of body measurements recorded during an anthropometry study of Richard Dupont's body conducted November, 2004, at Wright-Patterson AFB with General Dynamics.

obtain through a similar though less comprehensive digital dossier compiled using data-mining software aptly named *Carnivore.*

The "soft cage," as the entire multi-tentacular apparatus of surveillance has come to be known, appears reasonable to the general public because, as conventional wisdom promises, the honest have nothing to fear and the guilty have only themselves to blame. As we power up the nanny cams, surf the web leaving cookie trails, or access our new Dell or Compaq laptop with a simple finger scan, it becomes increasingly clear that the effects of this electronic dragnet are constant even when its application may be intermittent. When we cruise through a toll booth at a comfortable five mph, congratulating ourselves for the small convenient miracle of our EZ-Pass cards velcroed to the windshield (right next to the suction-mounted GPS system and the bobbing fuzzy dice on the rearview), how many of us stop to think where this scanned information is going or, more specifically, how it is being used against us?

You guessed it. Dupont does. He explained to me how the growing culture of surveillance, as practiced by companies with vaguely Orwellian sounding names like Identix and Visionics, attempts to achieve discipline and create docile bodies by causing the subject of observation to police themselves; that is, to make a morally correct decision by "internalizing the gaze" of their faceless overseer. The closed eyes of each of his digital doppelgangers, then, do in fact physically subvert the gaze of the viewer, short-circuiting a kind of intimate human-scale empa-

thy; but more importantly they metaphorically reflect, in their hooded deep slumber, this very kind of inward-looking hesitation caused by an insidious system of dataveillance—a system, mind you, that is frighteningly simply because it is so mundane, decentralized and convenient.

In a technologized landscape where the Pentagon wants to accurately identify people at 500 feet using "gait analysis," the unique, metronomic rhythm of our stride, or "feature mapping systems" that measure 80 facial structures such as distance between the eyes, cheekbone formation and the width of the bridge of one's nose, it hardly bears mentioning that when future generations pause to reflect inwardly on their tortured souls it won't be in a contemplative effort to plumb the depths of their sensitive *Volksgeist* in search of a trenchantly zippy sonnet to encapsulate the moment, but rather with the cautious tentativeness of one who knows he is being watched.

Often Dupont is asked why he even works in the somewhat dated medium of figurative sculpture, a genre which over the years has easily been co-opted by Madame Tussauds and Industrial Light & Magic, not to mention fully mainstreamed by Duane Hanson's pop-uncanny rogues' gallery of photorealistic tourists in madras plaid Bermuda shorts, or Ron Mueck's triumphal apotheosis of the "gee-whiz" hair follicle in a Brobdingnagian six year old clutching himself in the fetal position. Narrative sculpture, in other words, firmly

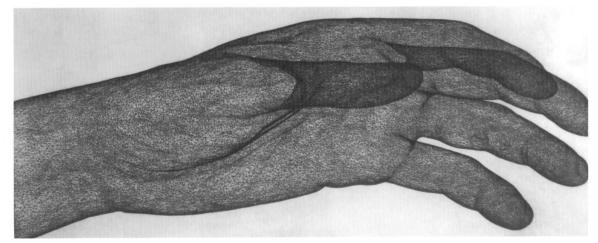

Phantom, 2007
Copperplate etching with aquatint on Rives BFK paper
39.75 x 63.25 in (100.97 x 160.66 cm)
Printed by Burnet Editions
Courtesy Carolina Nitsch, New York
Collection Whitney Museum of American Art, New York

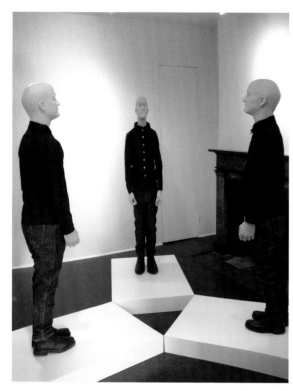

Three in One (self anointed), 2004–2005
Cast polyurethane resin, epoxy resin and handmade clothes on
artist's base
72 x 108 x 108 in (182.8 x 274.3 x 274.3 cm)
Courtesy Tracy Williams, Ltd.
Collection of The Museum of Modern Art (MoMA), New York

tethered to specific codes and rituals lodged in specific times and places.

Adopting the rhetoric of the soft cage, Dupont explained: "Dataveillance ignores one's physical body, the essence of which makes us uniquely human, in favor of tracking one's demographic, numerical twin. This 'digital leash' is really a way of mathematically subjugating us into groups to

create and exploit hidden niche markets through targeted direct sales. In a commercial marketing sense, dataveillance transforms us into a 'marketed species' with a subtly felt, but nevertheless real sense of compromised personal freedom, whereas my sculpture is kind of this hallucinogenic attempt to re-embody that sense of tactile, alienated human presence that is lost in this constant barrage of anonymous sales pitches."

"I try to make my figures as inviting and non-confrontational as possible. In a way, they are like giant injection-molded toys, G.I. Joe action figures stripped of any distracting uniform to better tap into a child-like nostalgia for platonic forms. The more simple the form is, the more dramatic the tension becomes between the highly specific conceptual aspect—an archived mass of accumulated information with no inherent spatiality—and the physical side, an *actual* mass or volumetric form carving out space in the manner of Serra's *Torqued Ellipse*. I think you see this when an accountant or a lawyer or someone who is just shopping in Midtown for a handbag is walking past the glass vitrine of the Lever House and suddenly just stops in their tracks, completely interrupting their perpendicular trajectory down Park Avenue. They seem to be drawn into the exhibition space like they were being pulled in by a tractor beam, so there's also this element of public sculpture as Situationist dérive, or a subversion of routine urban experience defined by the grid. And then I've seen tourists with backpacks or whole families even who actually begin touching these figures—almost cuddling them, really—as if these 80-inch sentinels were some kind of sci-fi petting zoo out of the bar scene in

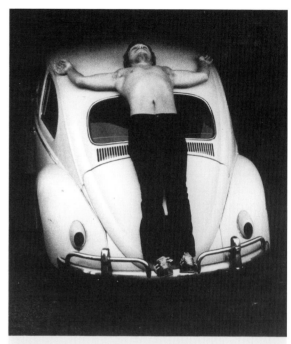

Trans-fixed
Venice, California: April 23, 1974

Inside a small garage on Speedway Avenue, I stood on the rear bumper of a Volkswagon. I lay on my back over the rear section of the car, stretching my arms onto the roof of the car. The garage door was opened and the car was pushed half-way out into the Speedway. Screaming for me, the engine was run at full speed for two minutes. After two minutes, the engine was turned off and the car pushed back into the garage. The door was closed.

Chris Burden
Trans-Fixed, 1974
© Chris Burden
Courtesy Gagosian Gallery

Star Wars. Despite the fact that they're all about the size of your average NBA small forward, spread out across the Lever House's checkerboard terrazzo tiles—a grid within a grid, so to speak—they become completely approachable."

Dupont's description of a privatized regime of observation sliding inexorably toward a cashless cyber-society in which every PayPal transaction is

recorded and correlated to a subject's location in time and space—an increasingly pervasive and ultimately totalizing environment of pixels, ring tones, junk mail and MP3 files—seems an accurate diagnosis of our plugged in, iPod generation. Conversely, the Greeks, to rewind/refresh for a moment, were compulsively counting stairs, repeatedly washing their hands and checking to make sure that the candles were snuffed out because their OCD arose out of a paucity of information; aside from the primitive legacy of the Egyptians, they literally had nothing to graph or chart as they sweated over their drafting tables. Data-gluttons that they were, the great Sophist Protagoras instantly became the new spokesmodel for this zeitgeist pathology when he coined the maxim, "Man is the measure of all things." Meaning, in other words, that subjective experience of the visible world, not a mystical sign handed down from above, was the exclusive determinant of reality. After all, the height of a typical kouros figure (and they are all typical) is a standardized length based on seven Greek heads.

Now fast-forward to the twenty-first century. An almost breathable atmosphere of data-smog suffuses our every activity, creating a cognitive dissonance that constantly takes us out of our bodies. The Greeks had zero information and were known to be serious nervous wrecks; we have the information superhighway and, well, you get the picture. I'd hazard that competitive yoga, doubtless the extreme sport of our accelerated age, will soon qualify for the next Olympic Games—such is the extent to which we are alienated from our own extremities. Further, this constant buffeting of our bodies by the heavy weather of data—if viewed in

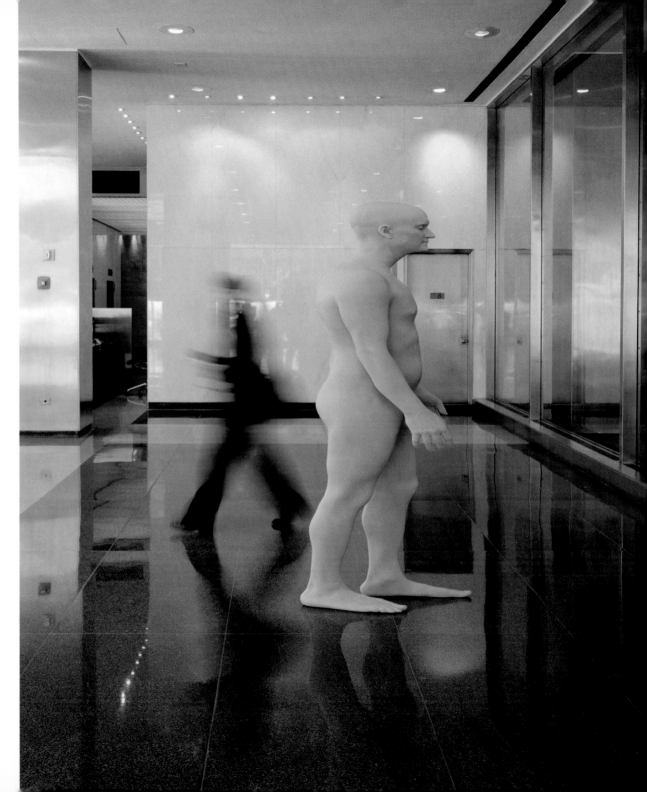

32

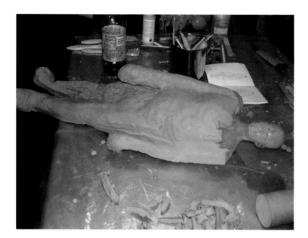

Work in process, 2006

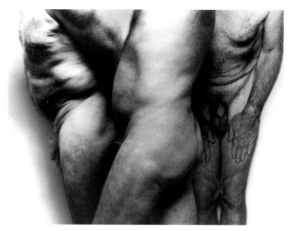

John Coplans
Self Portrait, Three Times, 1987
Photograph
© John Coplans Trust

balloon—a sly, if perhaps unwitting, nod to the illuminating gas Duchamp "injected" into the nine malic molds that gave birth to his Bachelor Machines, imbuing them with a desiring soul.

Dupont, by contrast, in his conceptual use of the 3-D body scan, embraces and even valorizes the digital legibility that is the grail of surveillance—propping it up, only to knock it down—but *superficially* his surrogate figures have nothing to do with illustrating the kind of existential post-traumatic stress that is a byproduct of modern geopolitical horrors. Nor, it should be evident by now, are they conceptual cousins to the genre of taxonomic self-portraiture in the Mannerist style of, say, Charles Ray's orgiastic pile of mannequins—slapstick odes to clichéd myths of artistic narcissism that they are. Hairless, naked and blessedly free of any individuating markers, Dupont's hyper-prosaic surrogates—timeless, precisely because they've stepped out of Hegelian, calendrical time—are far from Ray's psychotic suburban docudramas circa 1970s America, because at every potentially individuating juncture Dupont is maniacally insistent on keeping them as "generically mystical" as possible. When viewed at the Lever House in clusters of three (or nine, the mirror symmetry of three, the echo of the infinitely self-replicating triangular polygon), these healthily engorged Slim-Fast Buddhas practically become anti-self portraits: Everymen shorn of any biographical backstory (the Holy Trinity of race, class and gender) so that any viewer walking in off the street can not only impose their own narrative, trigger their own deep-sky celestial reverie, walk a block in their elongated, fallen arches, but actually *be* them.

the kinesthetic sense of skeletal warpage, at least—would inevitably seem to lead right down the gilded bronze path of Giacometti's emaciated human figures stuck asymptotically in a perpetual La Brea Tar Pits of the mind. That is to say, Giacometti illustrates the moral hemophilia of WWII and its attendant existential despair with shrunken figurines whose bodies appear to cave in on themselves, slowly sinking into the fetid, marshy puddle of DNA from whence they originally arose.

Here, "the ruins in reverse," to unpack our entropic muse Smithson, are no longer decaying drainage pipes on the Jersey turnpike, but rather a race of blighted humans modeled by Giacometti as if the war's atrocities—its collateral psychic damage—is alchemically transformed into a physical drag coefficient winnowing the flesh right off the bone. Likewise, Dupont's nine orphaned avatars at the Lever House, standing at parade

rest with arms akimbo, scan an unknowable and infinitely distant horizon like searchlight beacons. Taken collectively, they indeed echo the five figures in Giacometti's *Piazza* of 1947 in that each seems to exist independently of each other, their multiple, non-converging paths suggesting individual ambitions and absorptions; but that's about where the similarities end. While Giacometti's clubfooted, withered Everymen are firmly grounded in smelted terra firma, Dupont's nine figures, reanimated with a techno-vitalist spirit, appear to be both primed for liftoff on the Lever House tarmac—just barely kissing the marble with their splayed feet—and practically rooted to the structural pylons of the building like giant sequoias in an enchanted old-growth forest. As you approach the installation from about a block away, you get the impression that the janitors must be stoking some unseen blast furnace, pumping hot air into the room as if it were some gigantic I-Style helium

Marx famously said that "Milton produced *Paradise Lost* as the silkworm produces silk, as the activation of his own nature," and similarly Dupont has created a generic vessel that seems to induce as many kinds of unique reveries as exist available spectators to conceive of them; each ultimately experiences the activation of their own authentic self. Amateur console cowboys and syndicated cyber-pundits alike call this transcendental turn of mind "The Theology of the Ejector Seat," the floaty notion that Modernism's mind/body dichotomy is being gradually superseded by the trichotomy of mind/body/machine. And no doubt when one steps onto Noguchi's tessellated arena in the Lever House, primed by the spectral wraiths Dupont has inserted into this modernist human terrarium, one imagines the spongy pink curves of their back-sides emblazoned with the red-state bumper sticker: "Warning: In Case of Rapture, This Vehicle Will Be Unmanned." An evangelical rimshot reminding us that the Cartesian mantra "I think, therefore I am" may be winning the Enlightened twenty-first-century war, but is daily losing the battle waged in the Zero-Zone trenches to Dupont's more metaphysical, anti-rational ethos: "I feel, therefore I am immortal."

And this, as I've tried to argue, is precisely the point. In using a system of irregular triangulation to spread out his posse of Unfrozen Caveman Lawyers across an expanded yet architecturally circumscribed space, Dupont not only tests the confining limits of the building's enclosing, sheltering trusses, but shatters them altogether. He literally makes them disappear. We forget they exist for a moment. We forget they *ever* existed. Given the protocols of site-specific public sculp-ture, Dupont's most radical aesthetic act (we realize minutes later after having moved on to the head bowed, prayer-like ritual of synchronizing our PDAs) becomes this intentional situating of his synthetic tribe in the built environment.

Now back in the world of power lunches and power yoga, of the retrospective clarity that cleaves to Masters of the Universe hammering out M&As as much as the lowliest admin-assistant-cum dharma bum centered in the Lotus position, the Eureka moment hits us in a seismic wave: Gordon Bunshaft's 1952 masterpiece of serialized glass and steel, whose hive design maximizes commercial retail space while speeding the flow of human traffic along Park Avenue, has, if only for a moment, been completely blown out, transformed—pace Smithson—into Pascal's infinite sphere where the center is everywhere and the circumference nowhere.

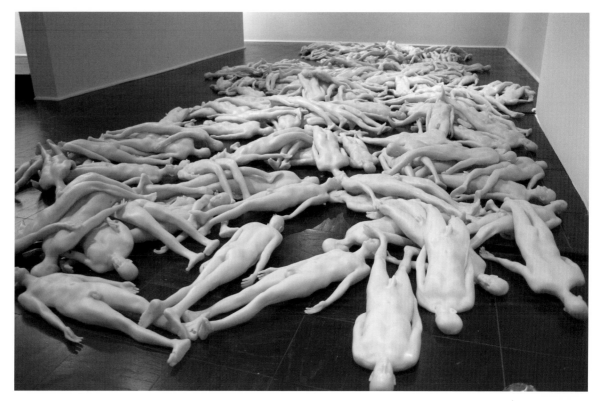

180, 2007
Installation detail, cast polyurethane resin
Dimensions variable
Courtesy Tracy Williams, Ltd.

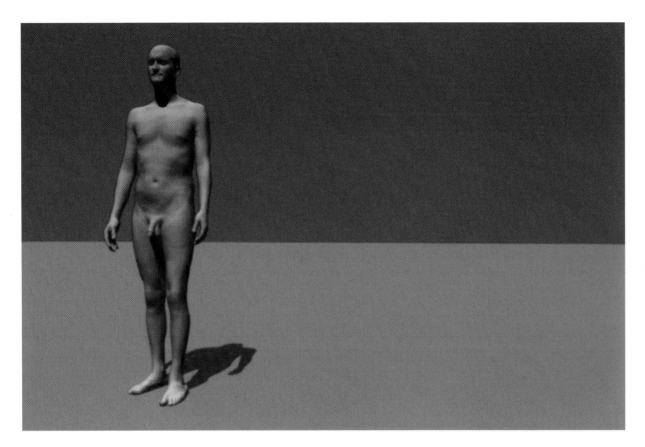

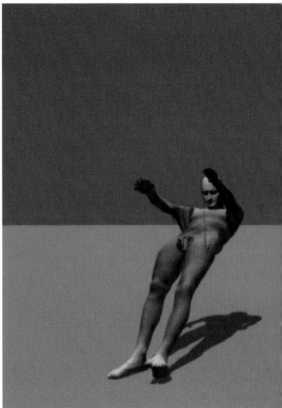

Fall, 2005
Digital animation

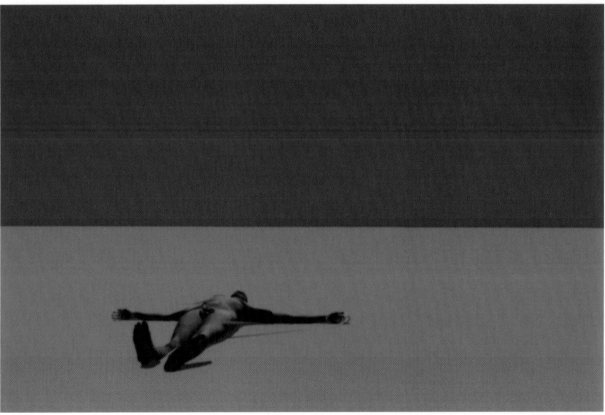

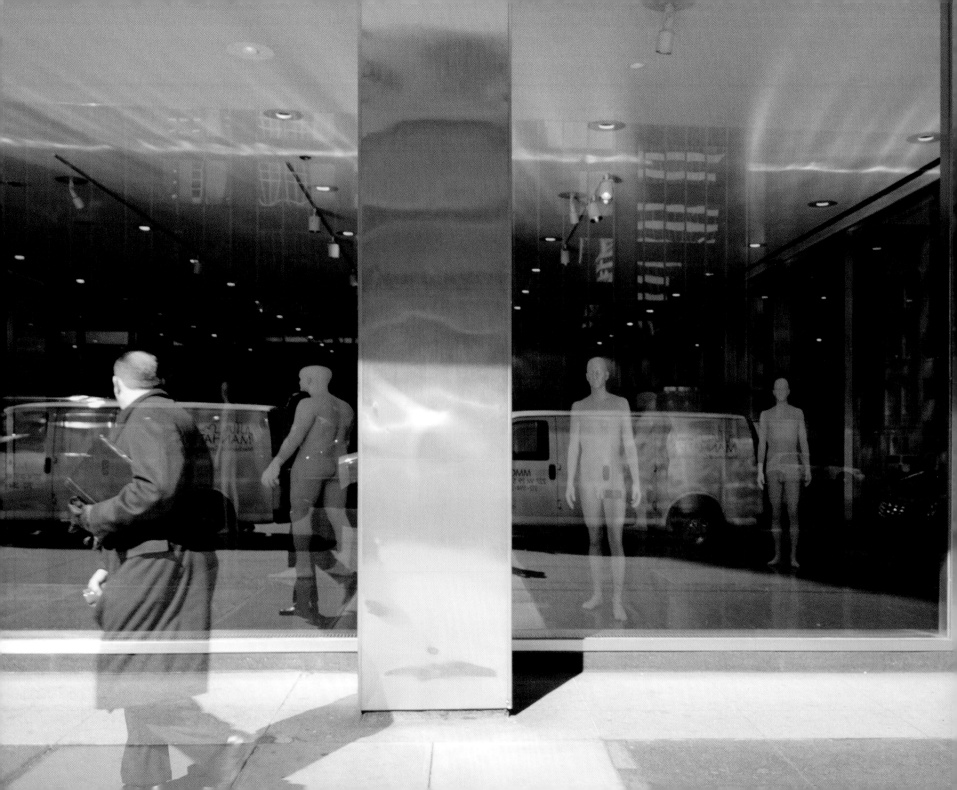

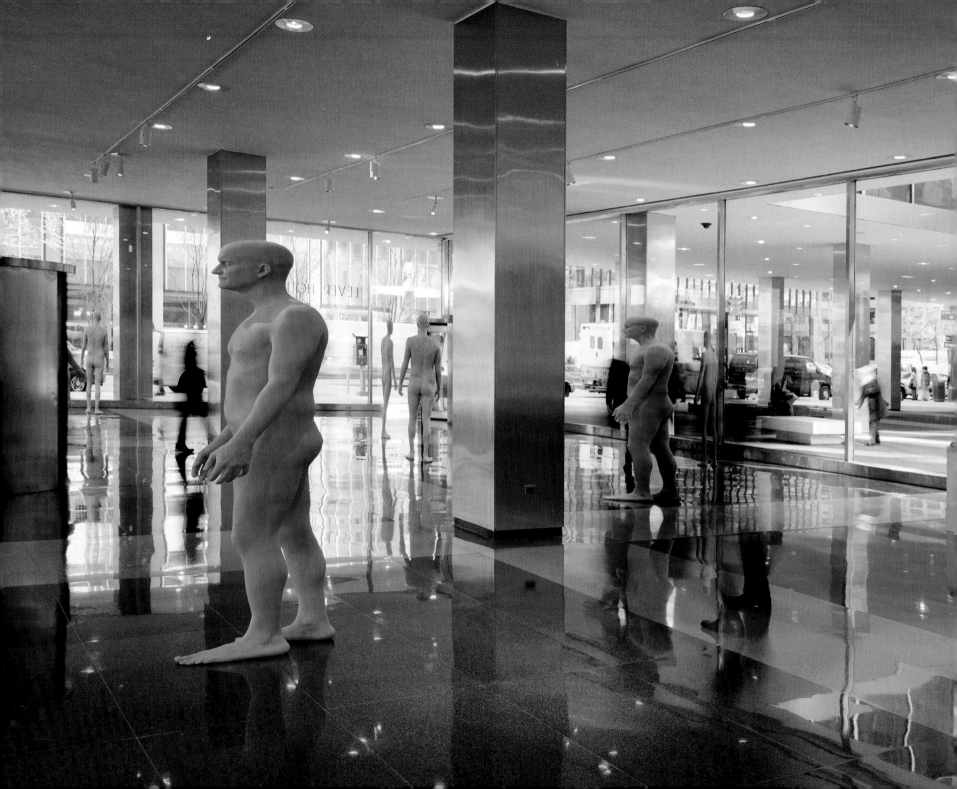

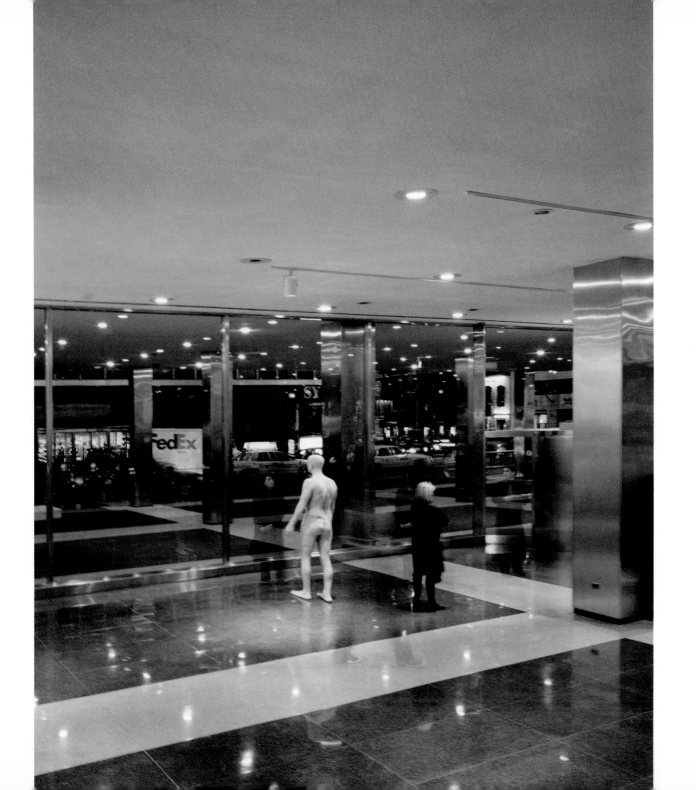

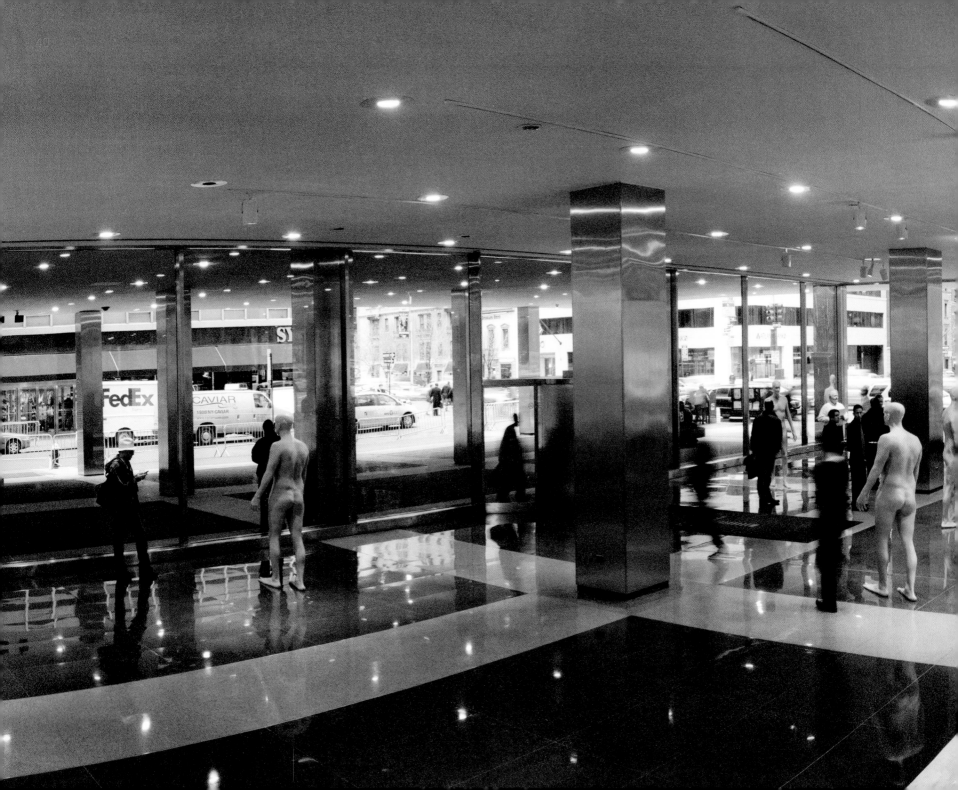

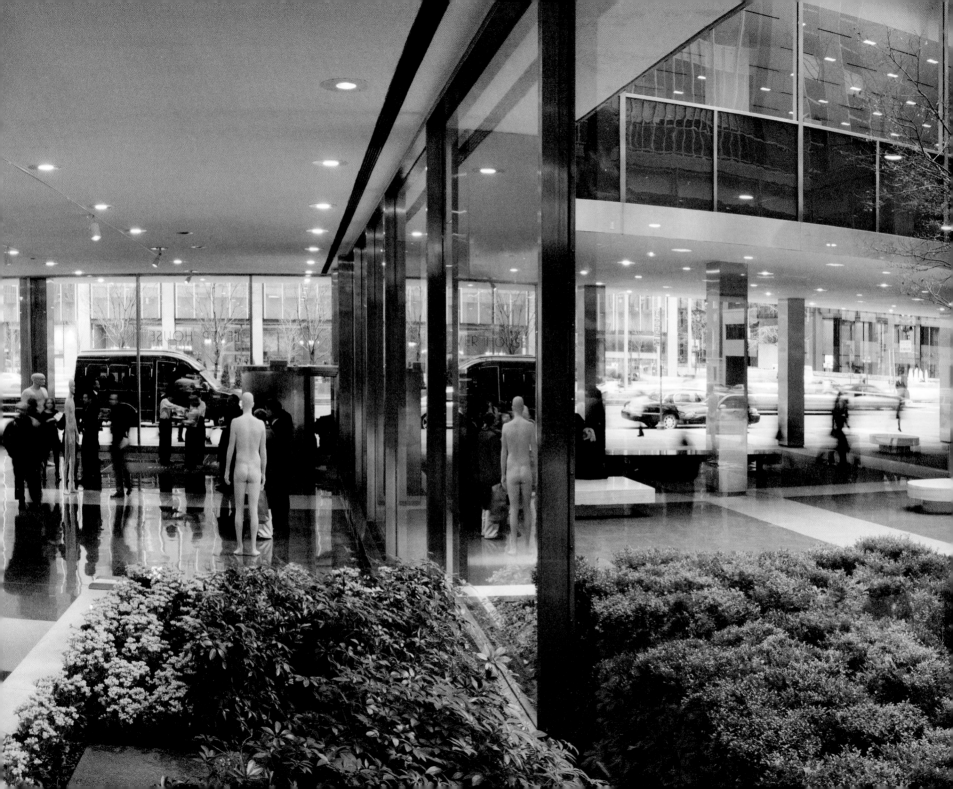

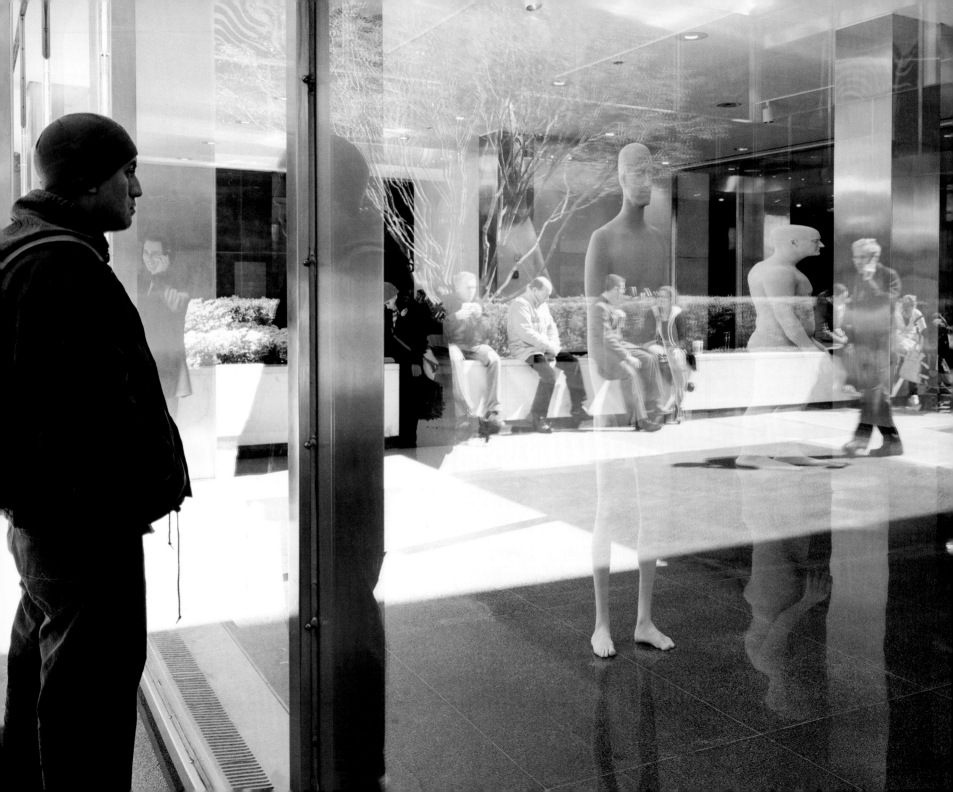

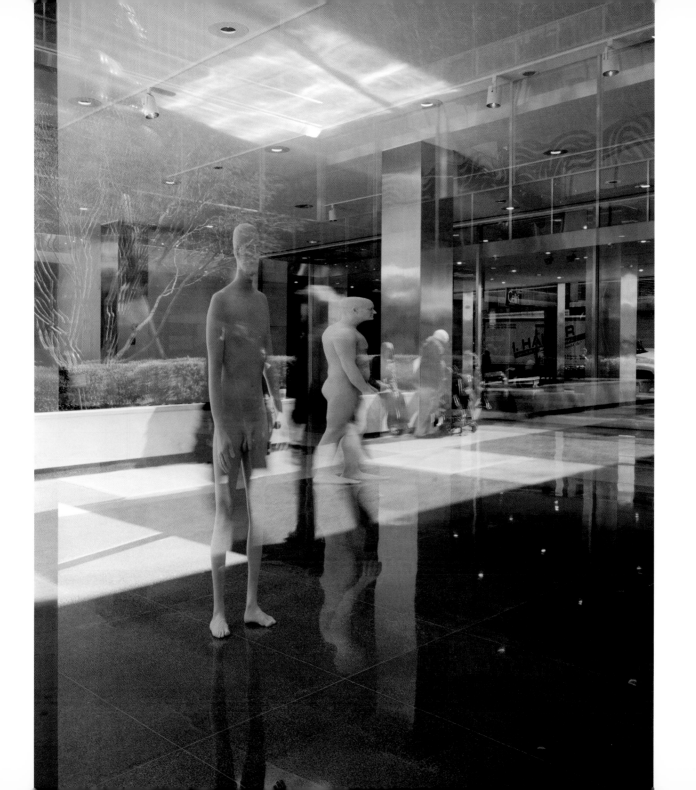

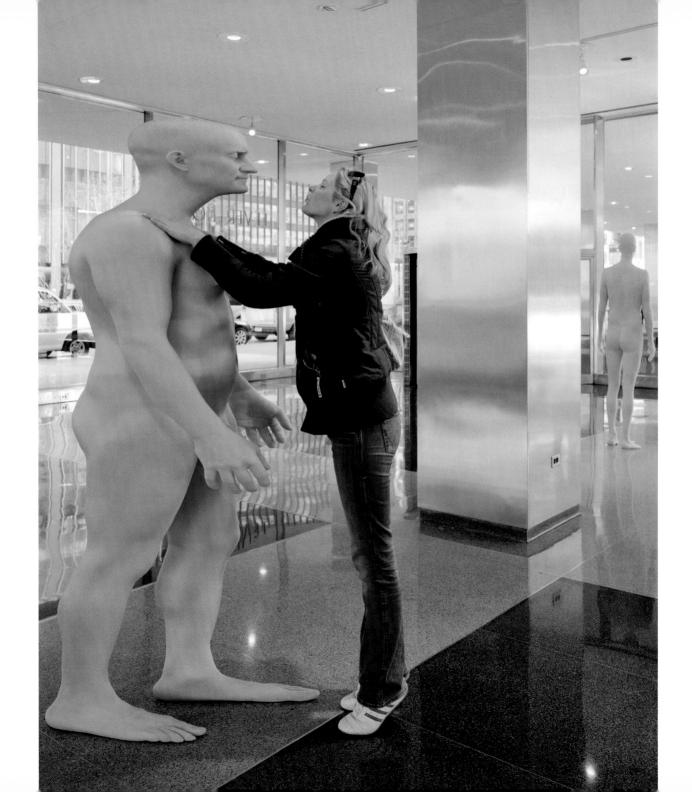

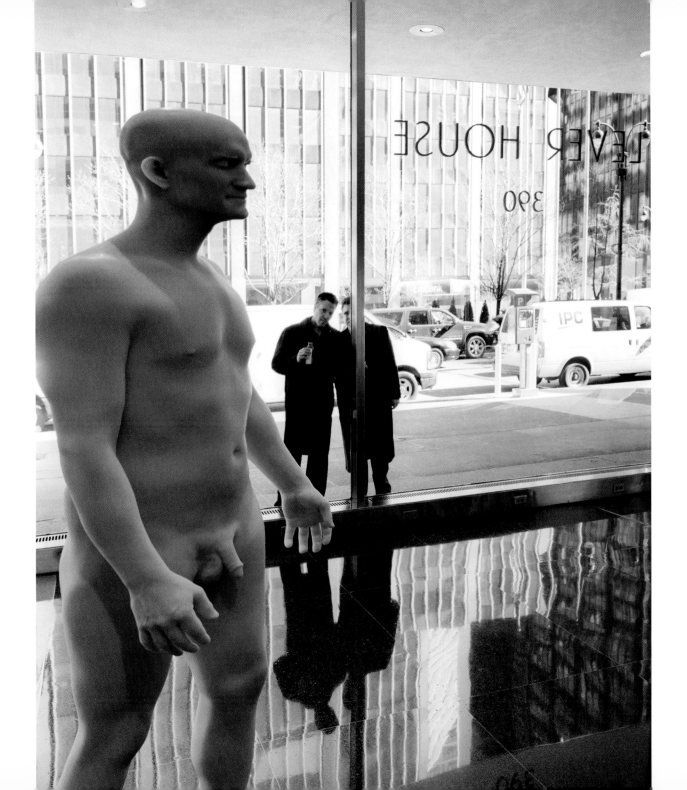

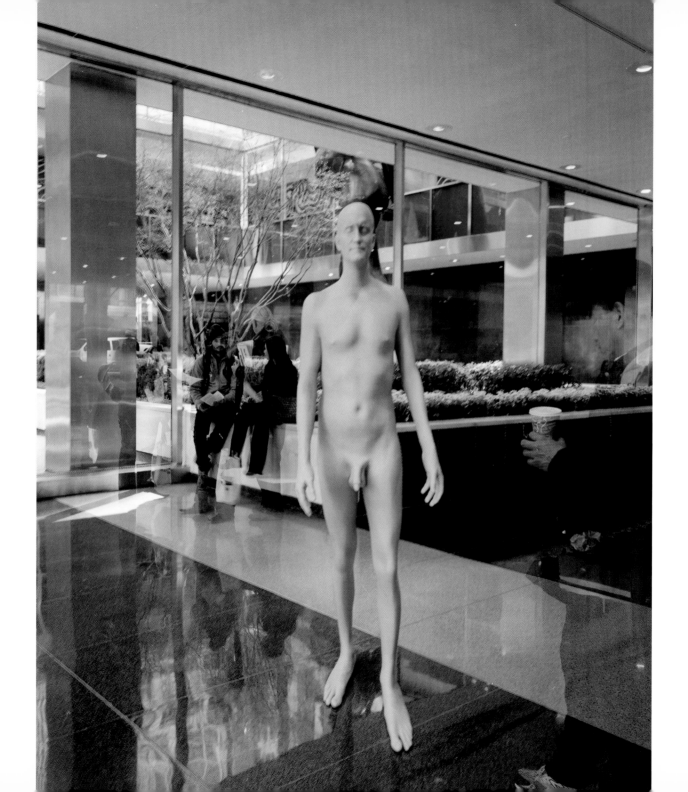

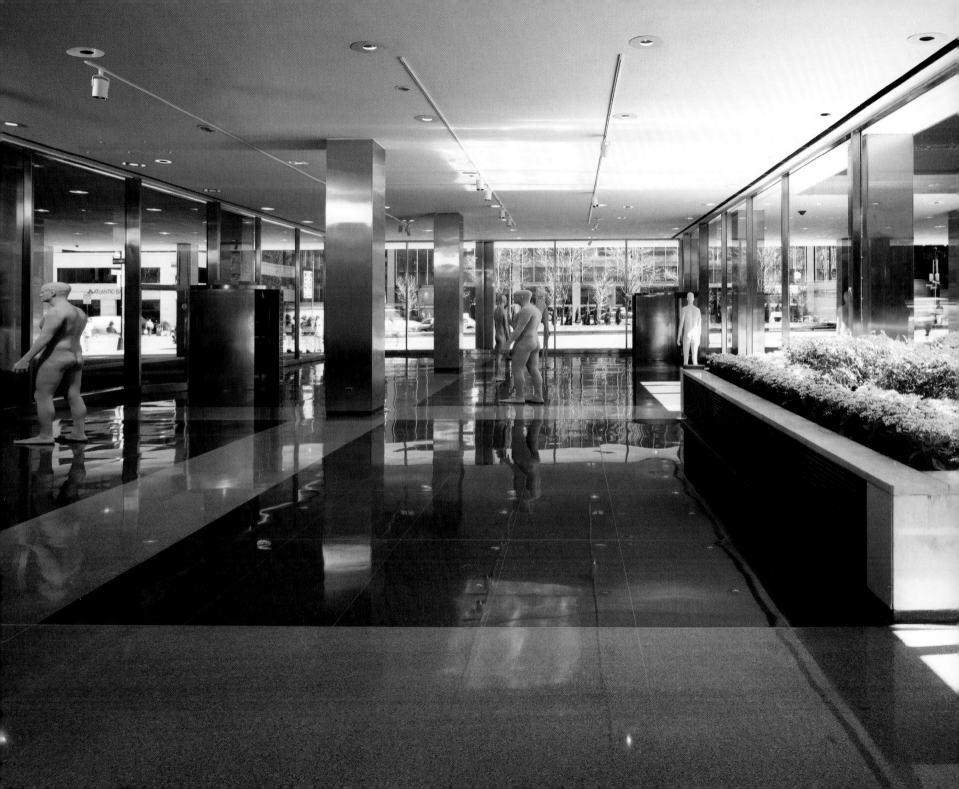

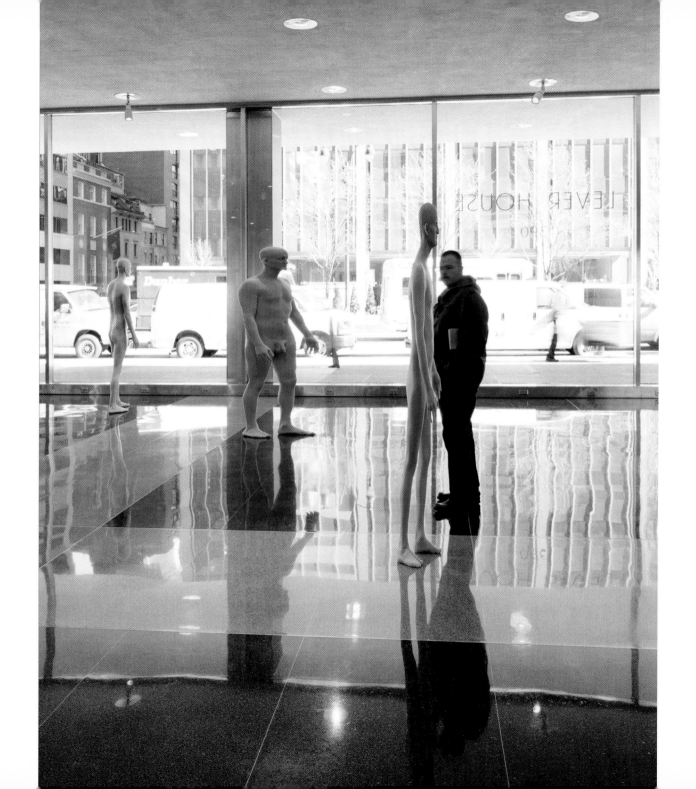

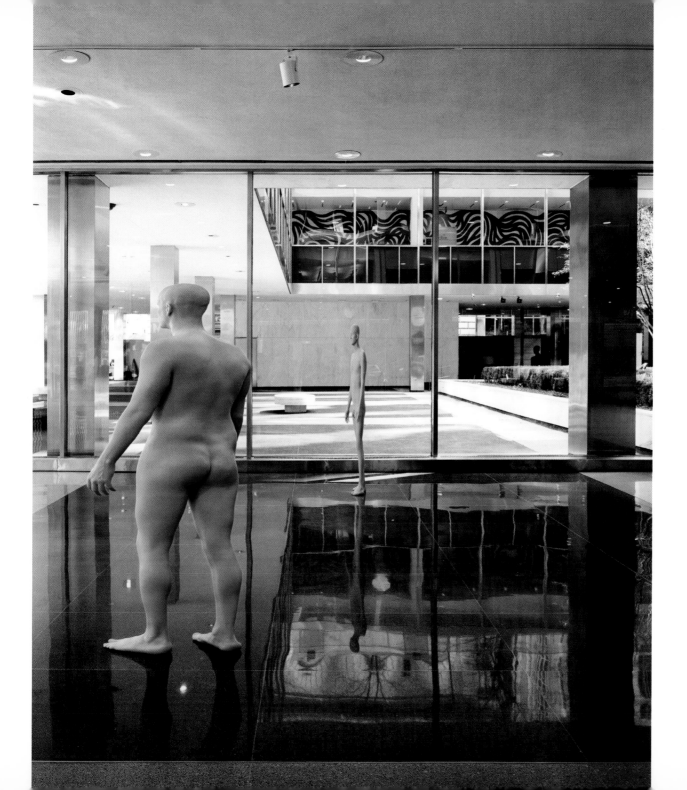

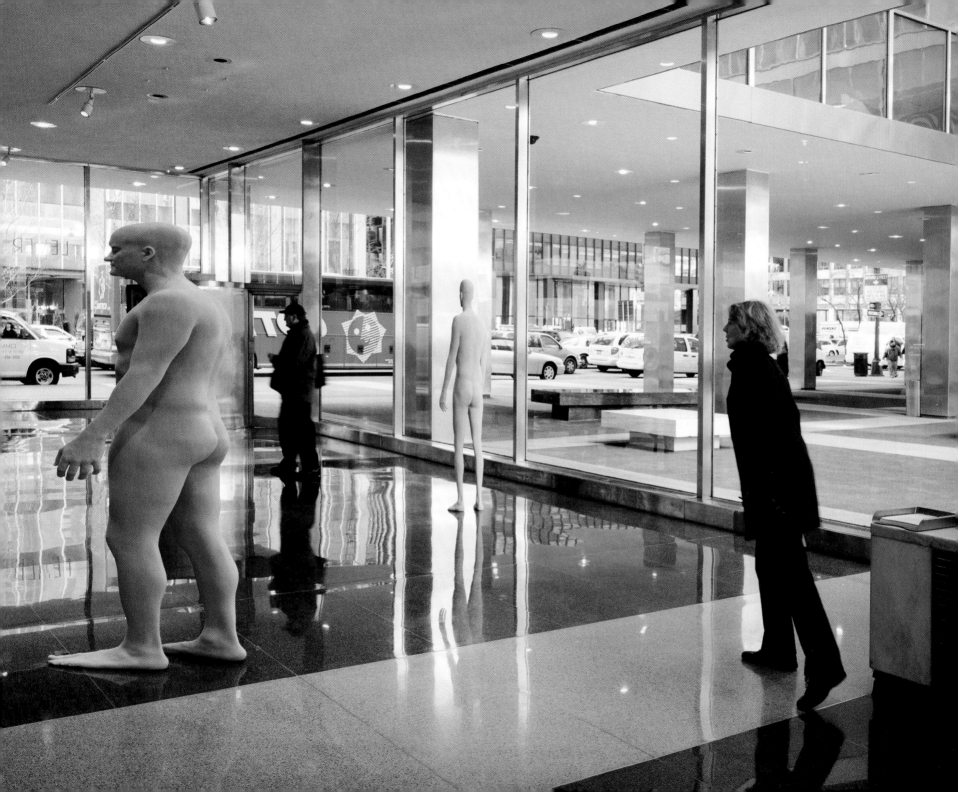

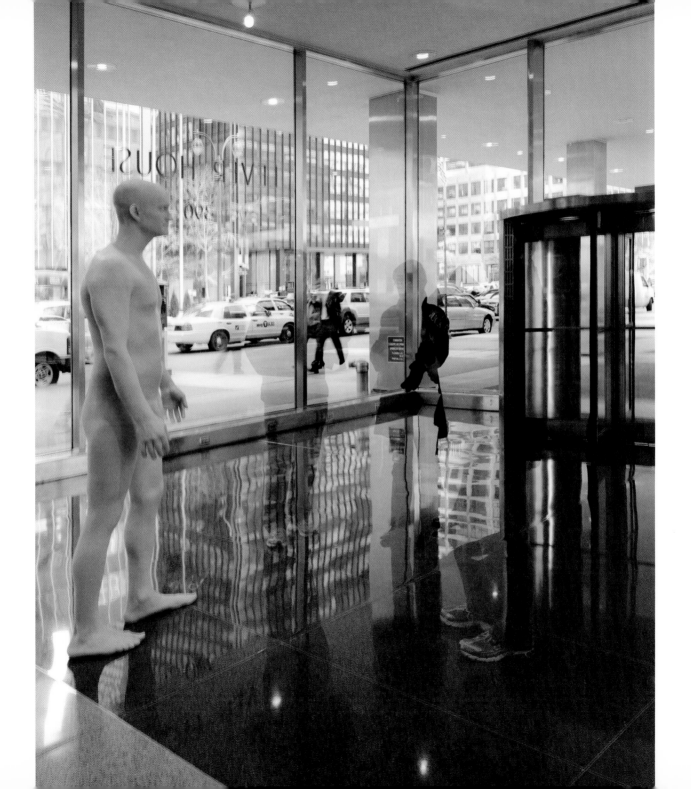

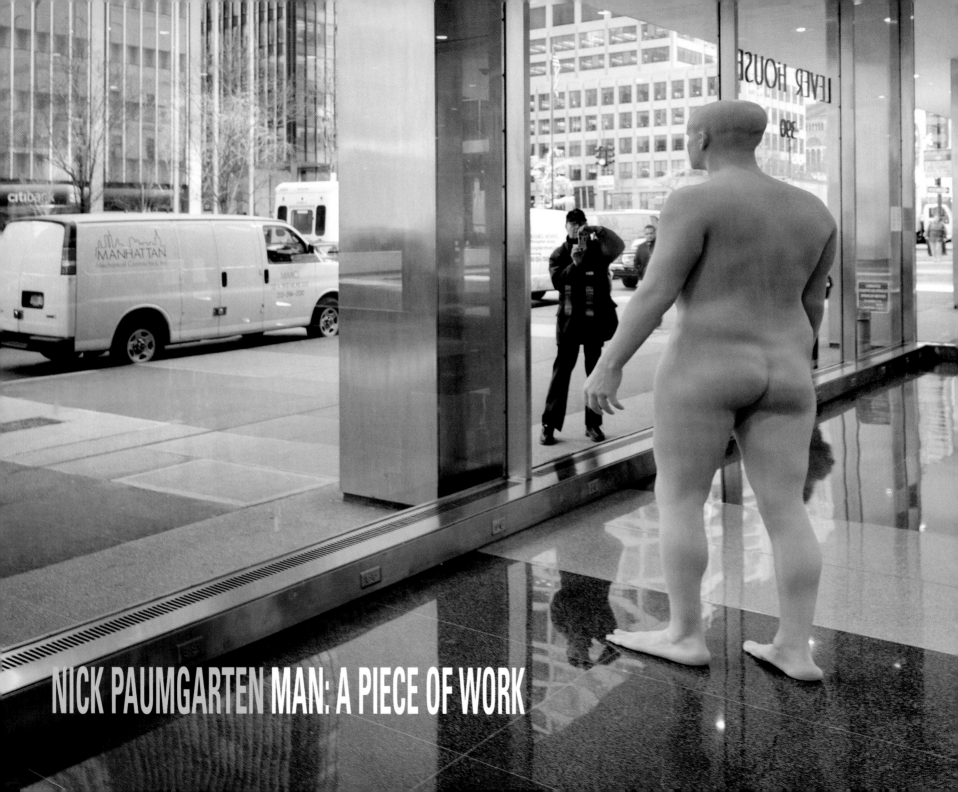

NICK PAUMGARTEN **MAN: A PIECE OF WORK**

Passengers seem to know instinctively how to arrange themselves in an elevator. Two strangers will gravitate to the back corners, a third will stand by the door, at isoscelean remove, until a fourth comes in, at which point passengers three and four will spread toward the front corners, making room, in the center, for a fifth, and so on, like the dots on a die. With each additional passenger, the bodies shift, slotting into the open spaces, as the brains perform their instantaneous vector calculations. The goal, of course, is to maintain (but not too conspicuously) maximum distance between bodies and to counteract the unwanted intimacies of enforced proximity—a code familiar (to half the population) from the urinal bank and (to the rest) from the subway. An animated YouTube gem called "Male Restroom Etiquette" (presented "in the interest of decreasing situations of lavatorial discomfort and furthering the cause of peace and harmony in the world") decrees that "under no circumstances should two adjacent urinals be in use at the same time" and additionally that no one should ever speak a word to anyone else in a bathroom. To violate these norms is to invite misinterpretation and violence.

Bodies need to fit. Designers of public spaces, especially of those whose primary function is the accommodation of pedestrians (as opposed to horses or cars or space vessels), have devised a maximum average unit size, with which to make their efficiency calculations. That is, they've figured out how much space a person takes up, and how little of it he or she can abide. The study of pedestrian flow is as indispensable as it is banal; a confined space—a train station, a stairwell, a lobby—won't work if the people seeking to pass through it can't do so without bumping into each other or getting stuck. Flow determines travel time, safety, mood. On regular days, congestion promotes annoyance and unease, an inkling of helplessness. In emergencies, it can lead to panic, madness, and death.

The wizard of the realm is John J. Fruin, the author of an obscure study called *Pedestrian Planning and Design*, which was published in 1971 and reprinted, in 1987, by Elevator World, Inc., an Alabama publisher of elevator-related books and magazines. (Fruin's epigraph may be from *Hamlet*—"What a piece of work is man!"—but his tone is *Dragnet* cool.) Fruin introduced the concept of the "body ellipse," a quantitative and graphic representation of an individual's personal space. This bird's-eye depiction of the human male—a shoulder-width oval with a head in the middle—is a pedestrian-design standard, a means of mapping the human form, for all its variations, on a two-dimensional plane. He employed a standard set of near-maximum human dimensions, drawn from numerous studies: 24 inches wide (at the shoulders) and 18 inches deep. If you draw a tight oval around this figure, with a little bit of slack to account for body sway, clothing, and squeamishness, you get an area of 2.3 square feet, which happens to be the body-space used to determine the capacity of New York City subway cars and U.S. Army vehicles. Fruin defines an area of 3 square feet or less as the "touch zone," at which point humans can't avoid touching each other. Seven square feet is the "no touch zone." Ten square feet is the "personal comfort zone." Edward Hall, an anthropologist who pioneered the study of "proxemics," called the smallest range "intimate distance"—less than 18 inches between people—at which point you can sense another person's odor and temperature. As Fruin wrote, "In crowded environments this requires special codes of conduct to signal that there is no intent of unwanted intimacy… Sight is often distorted, making this distance visually uncomfortable for some persons. Involuntary confrontation and contact at this distance is psychologically disturbing for many persons."

It may be worth noting that, in experiments with prisoners, researchers found that a "normal" inmate could tolerate a researcher's coming as close as 18 inches to him—that's within an area of 7 square feet—while violent or schizophrenic inmates required four times as much space. Fruin observed, "Environmental studies of lower animals have shown detrimental effects due to crowding, but potential human effects remain unknown." Anecdotal evidence—from crowded elevators, subway cars, sporting arenas, museum exhibits, and airport queues—suggests that the human effects are, at least, very complicated. Some humans thrive. Some go insane. And some do both, simultaneously.

BODY ELLIPSE

18" BODY DEPTH

24"
SHOULDER BREADTH

Images reproduced on pages 53, 54, 57, 58 courtesy of Elevator World, Inc.

ELEMENTS OF VISUAL COMMUNICATION BY SIGNS

THE PERSON

- physiological characteristics: sight impairments, color blindness, etc.
- mental capabilities: education level, memory, recall.
- familiarity, complexity of message, content: language difficulties, unusual terms.
- psychological attitudes: nervousness, uncertainty, fear, anger.

THE DISPLAY

- overall size and type of display: lighted, unlighted, etc.
- character size and type: alphanumeric, symbolic, geometric.
- brightness/contrast, resolution, visual phenomena, halation.
- coding by color or symbol.
- number of bits of information in display.
- esthetic values: letter style, materials, colors.

THE LOCATION

- viewing distance and angle.
- interruptions of line of sight, competing displays.
- display background relationship; ambient illumination, colors.
- physical configurations, statement of direction.

Figure 7.5

NOTE:
CEILING HEIGHT = 14'-7"

LOBBY

LEVER BAR

43'-5" 16'-4"

24'-7"

25'-6" 25'-6" 25'-6" 23'-4"

N

53 RD STREET BLOCK #1289
LOT #36
MAP #8D
ZONING DISTRICT

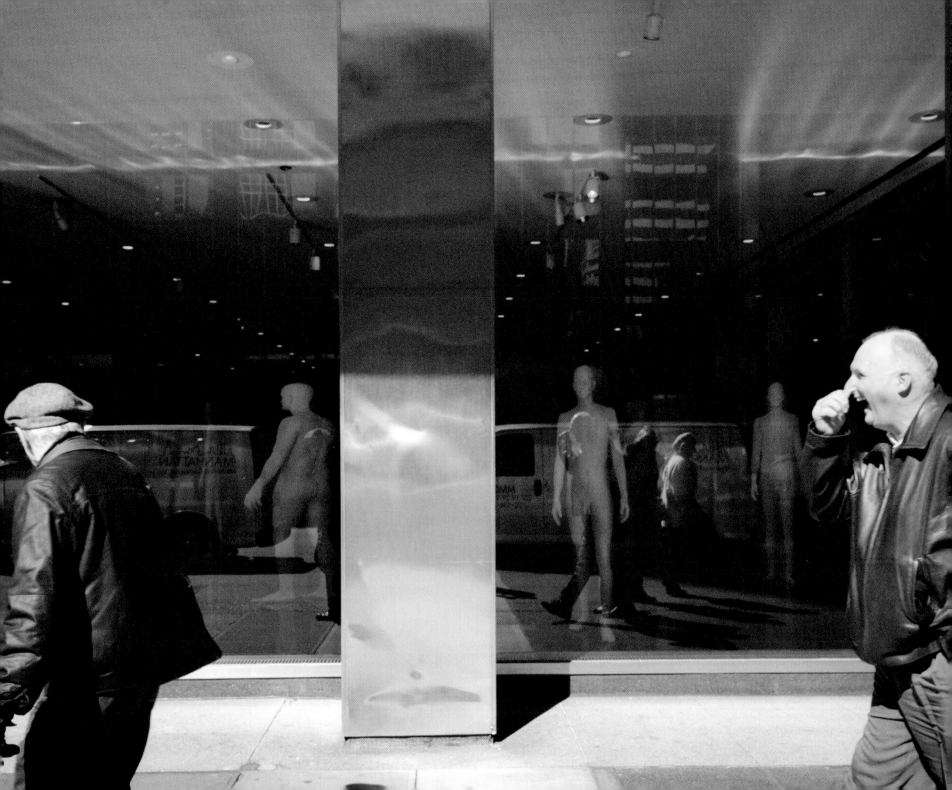

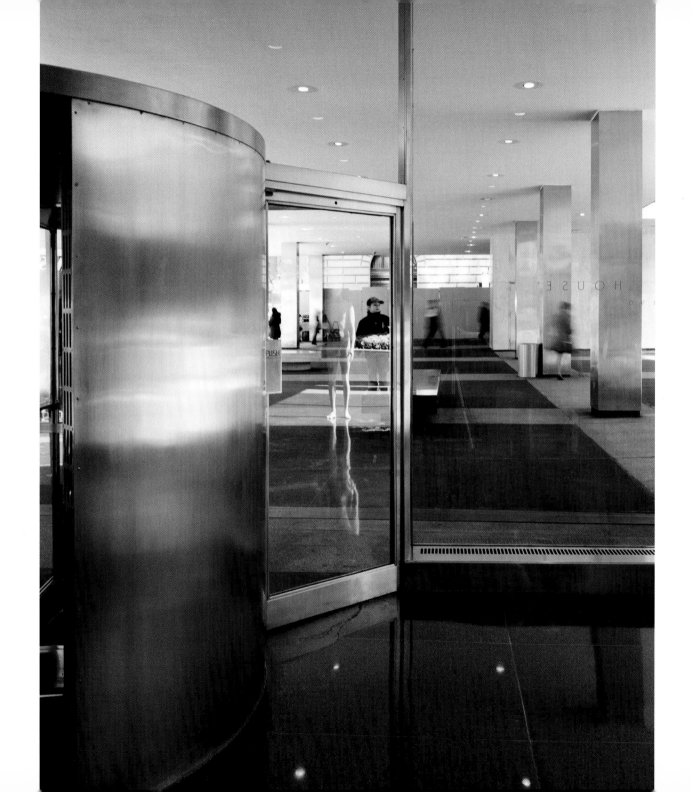

PEDESTRIAN QUEUING SIMULATION

Figure 3.17

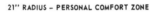

21" RADIUS — PERSONAL COMFORT ZONE

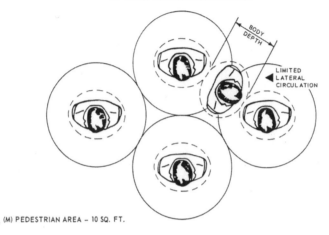

(M) PEDESTRIAN AREA — 10 SQ. FT.

24" RADIUS — CIRCULATION ZONE

Figure 3.18

(M) PEDESTRIAN AREA — 13 SQ. FT.

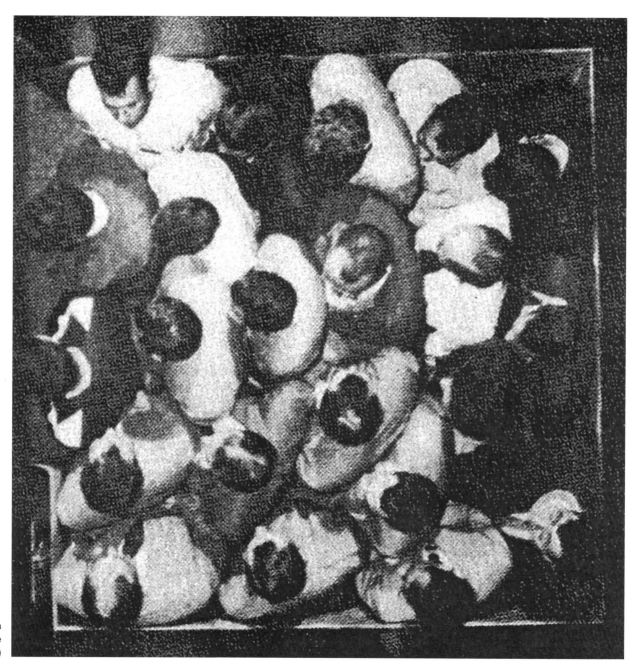

Average pedestrian area
occupancy of two square
feet per person (elevator)

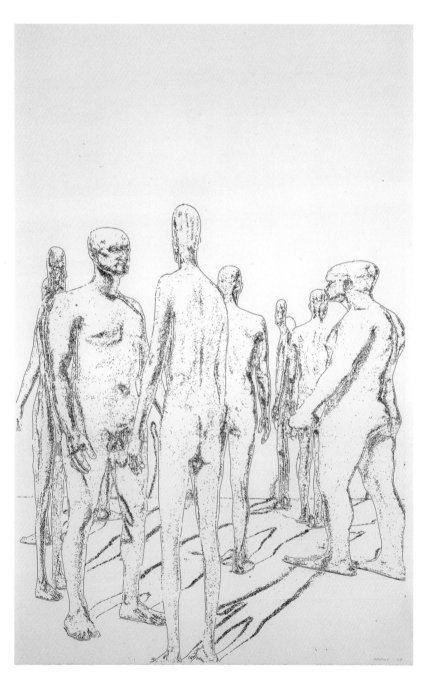

Drawing for Terminal Stage, 2007
Ink on paper
41 x 29 in (104.14 x 73.66 cm)

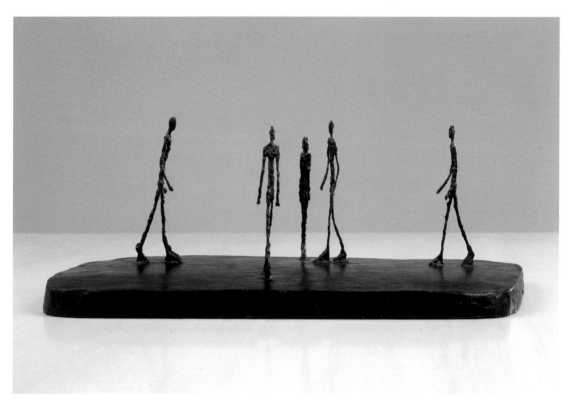

Alberto Giacometti
The Square II, 1948–1949
Bronze
23 x 63.5 x 43.5 cm (9 x 25 x 17 in)
Nationalgalerie, Museum Berggruen, Staatliche
Museen zu Berlin, Berlin, Germany
© Bildarchiv Preussischer Kulturbesitz / Art Resource, New York
© Artists Rights Society (ARS), New York

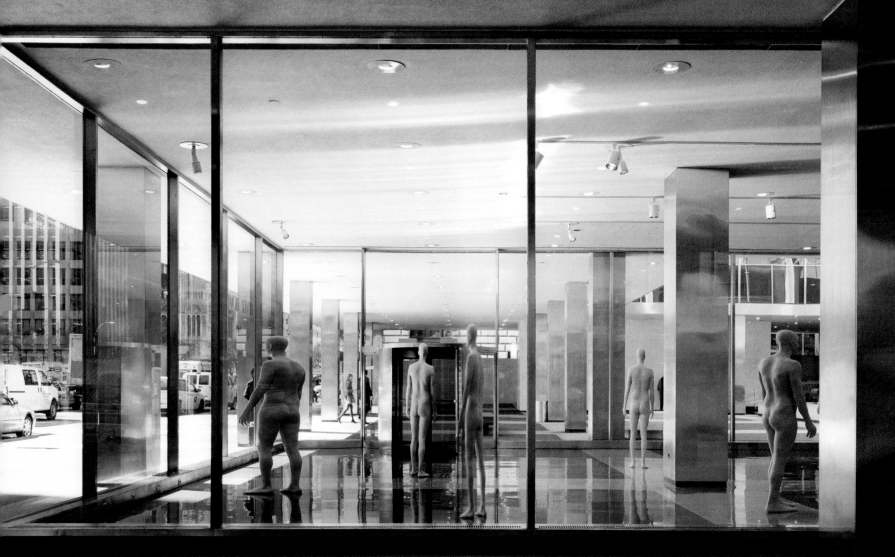

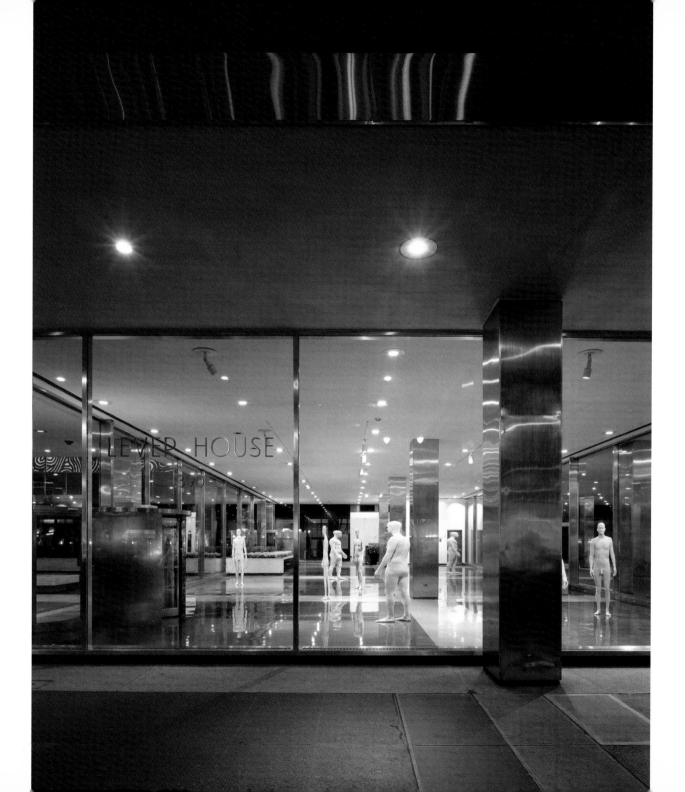

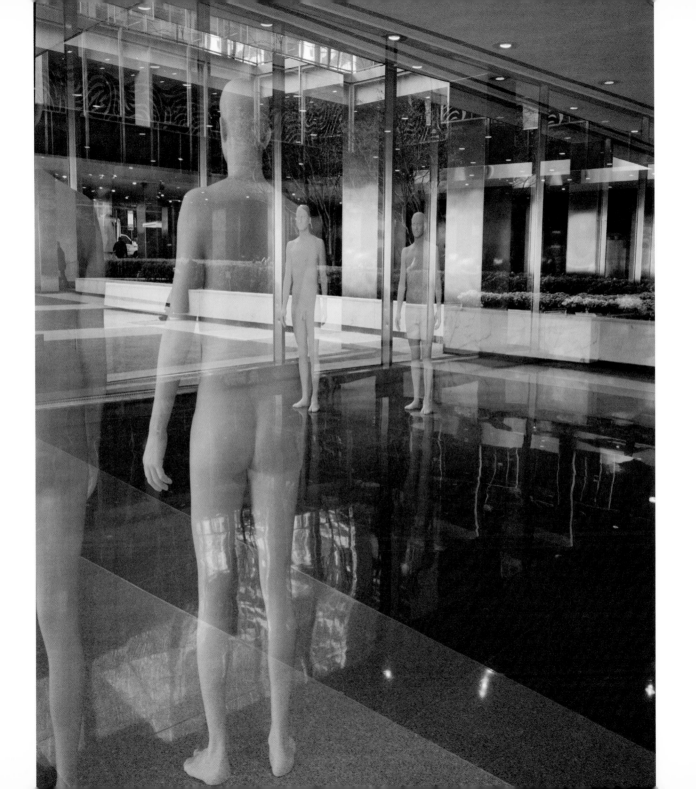

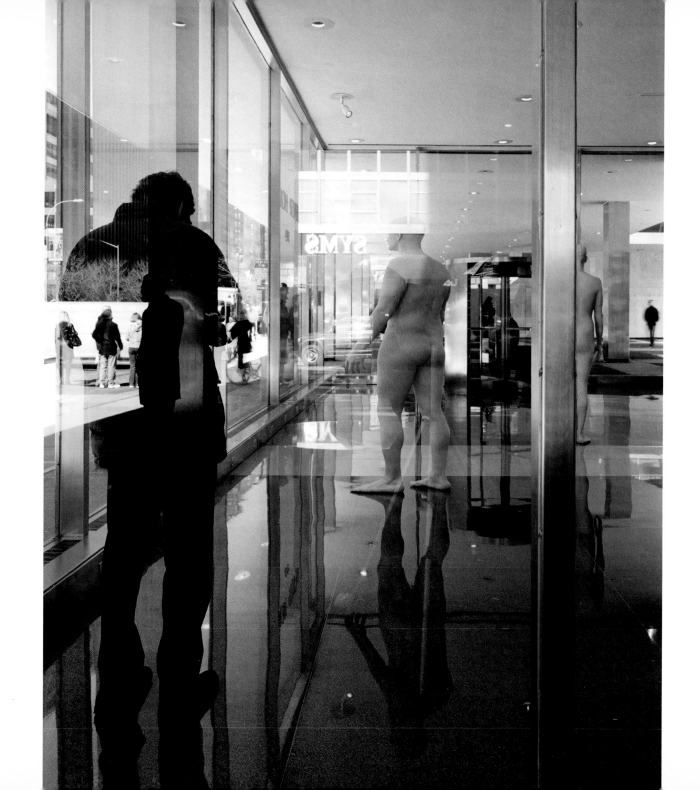

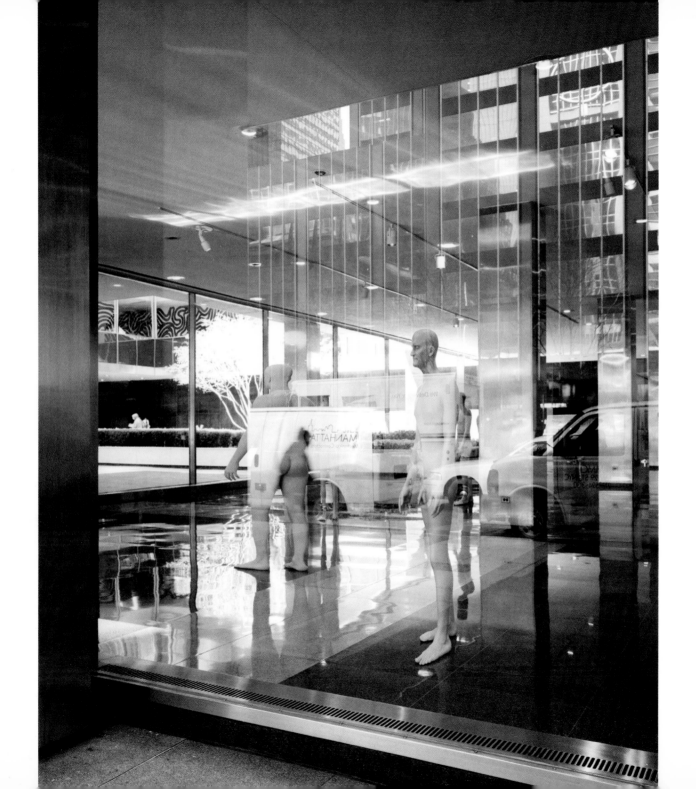

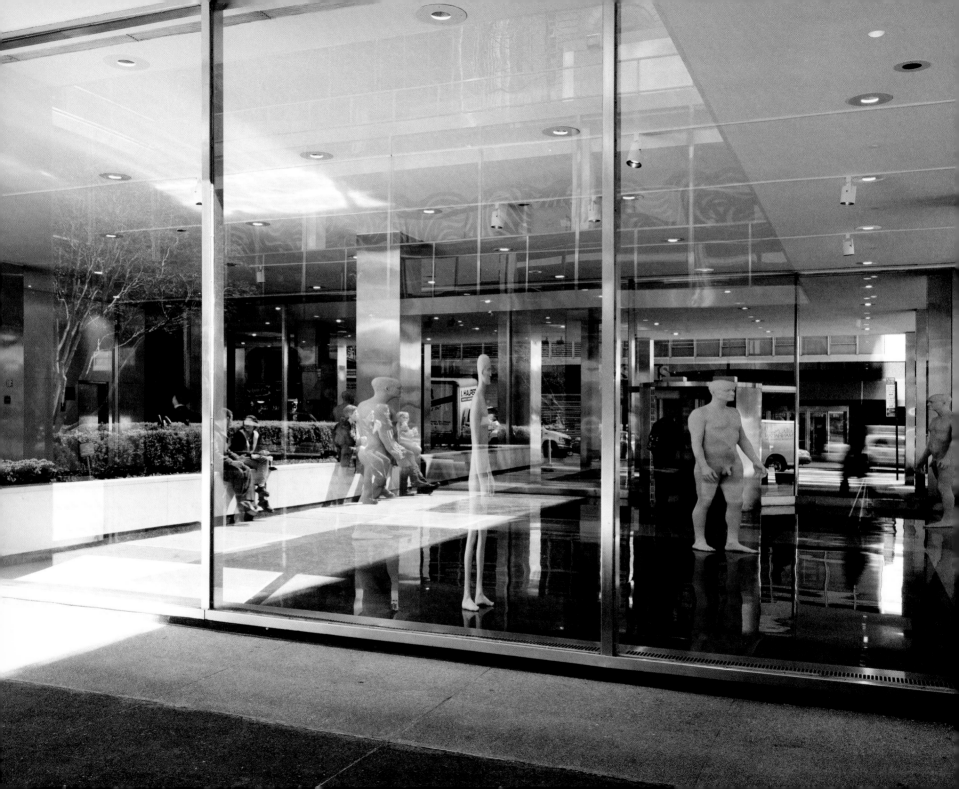

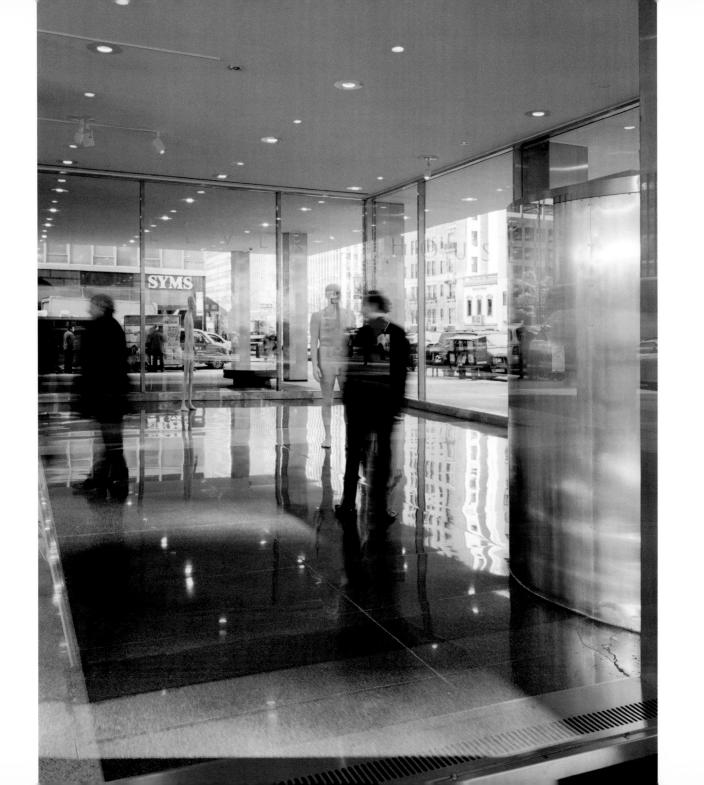

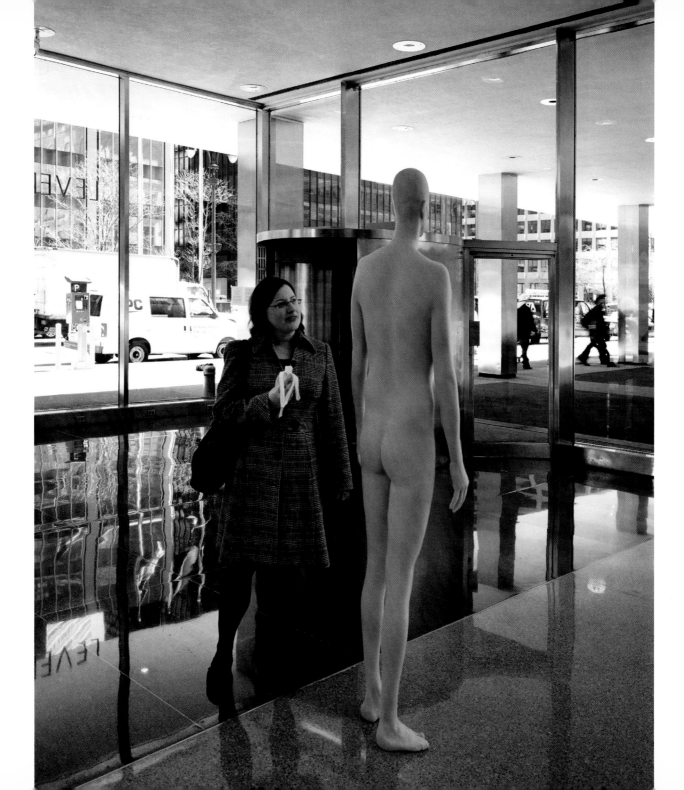

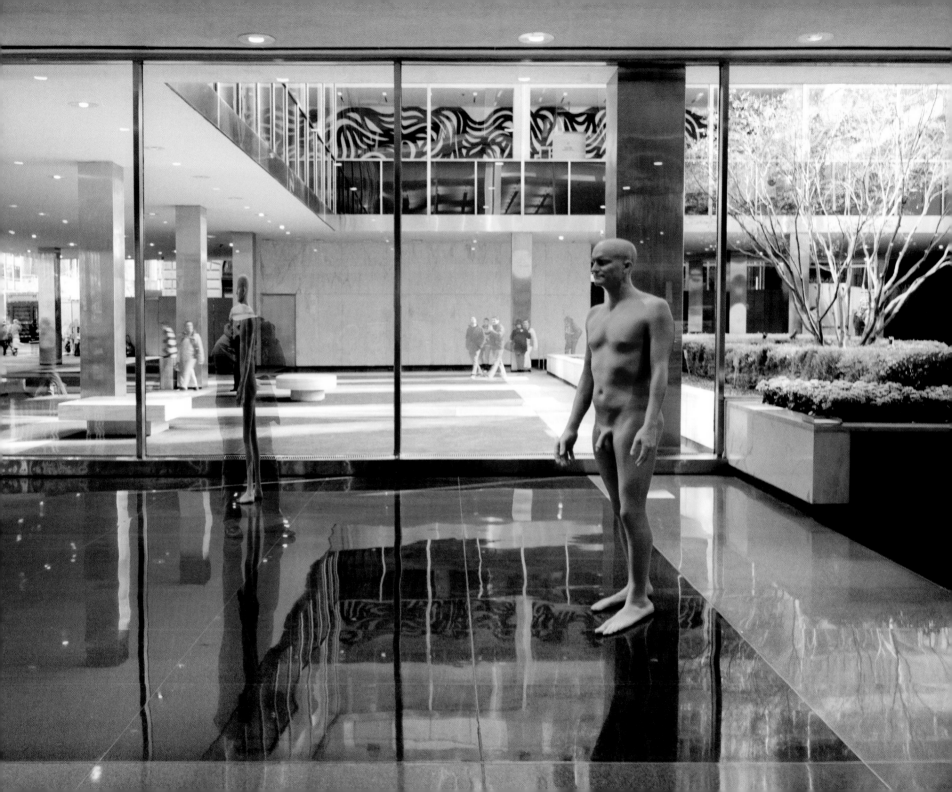

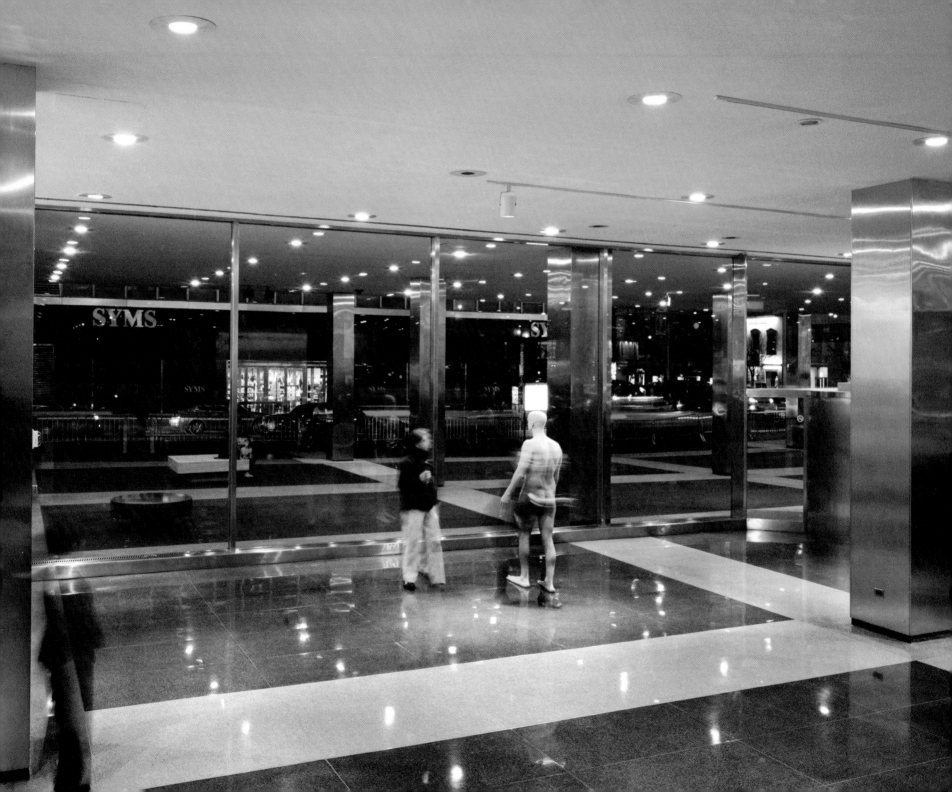

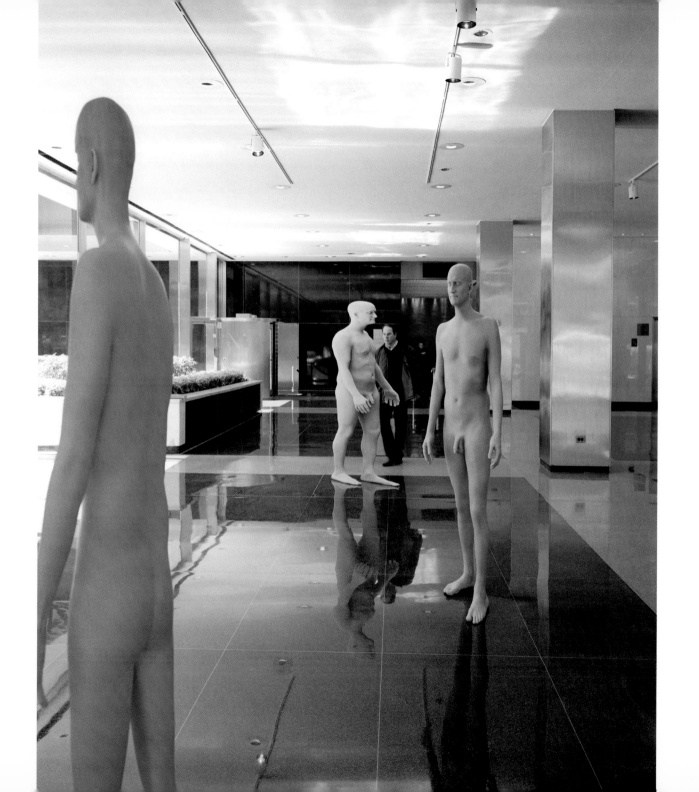

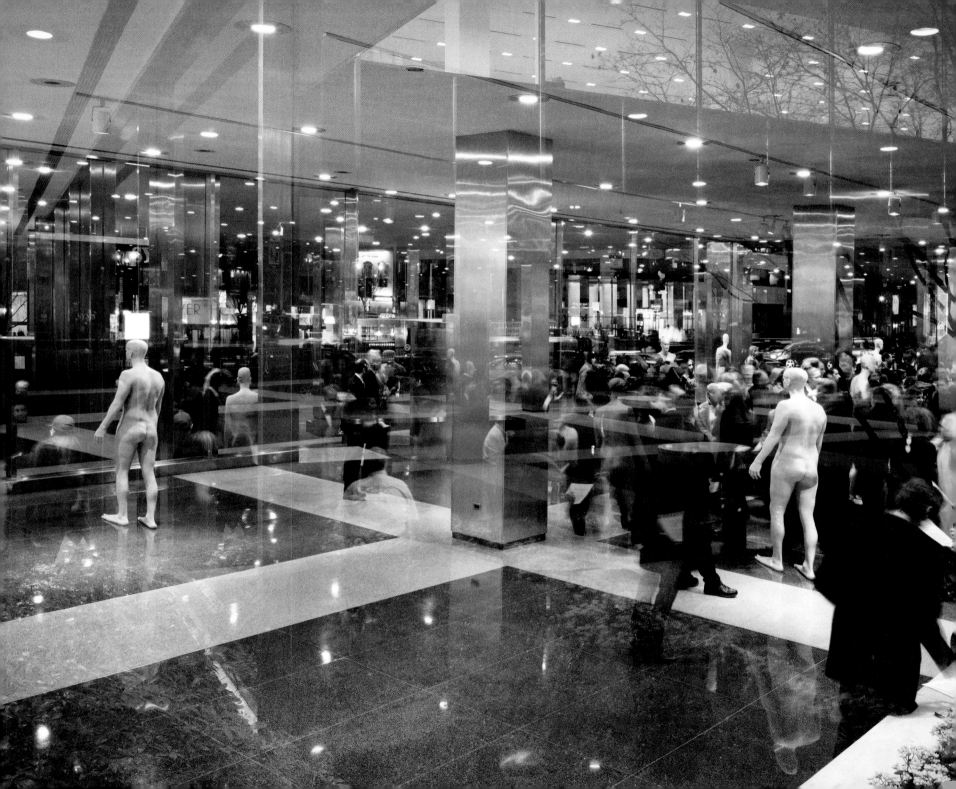

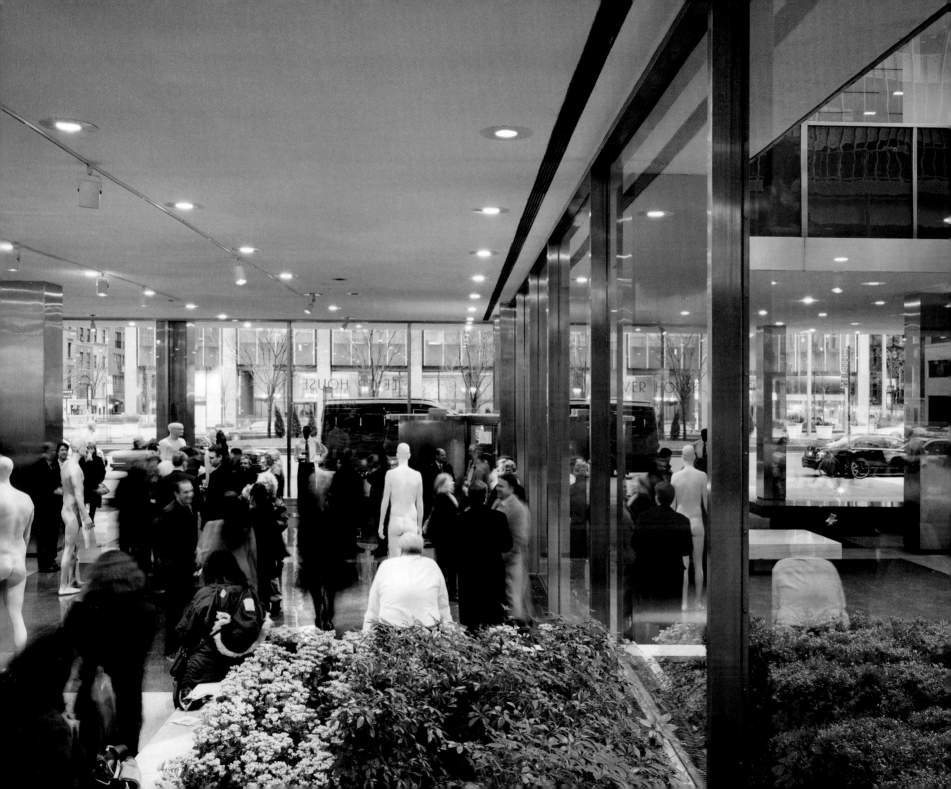

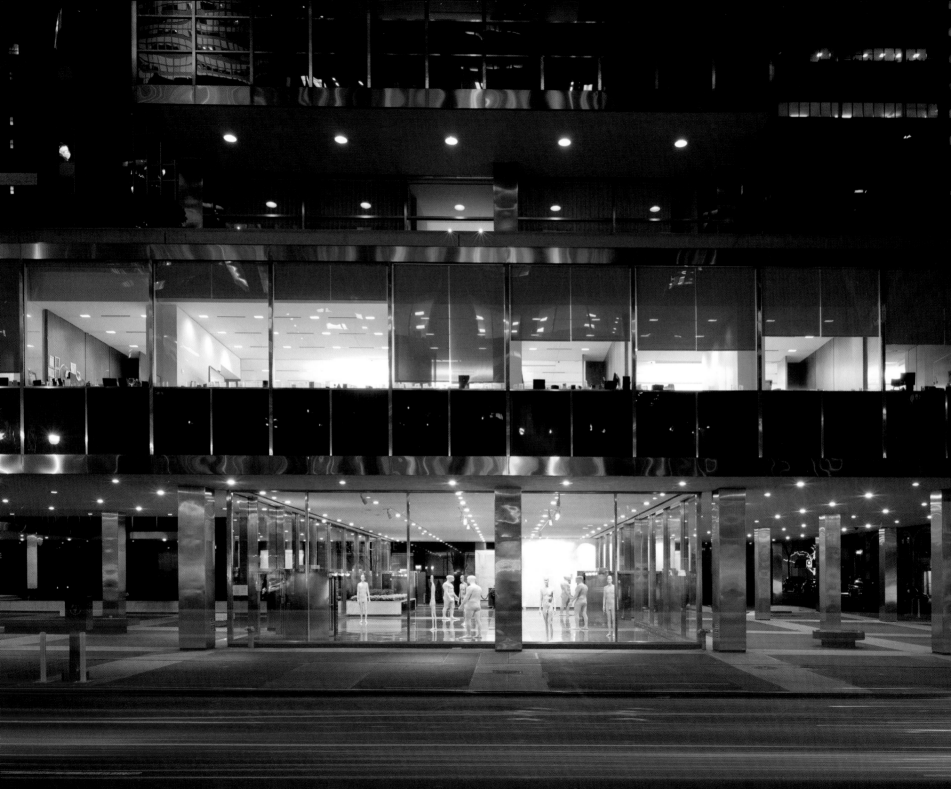

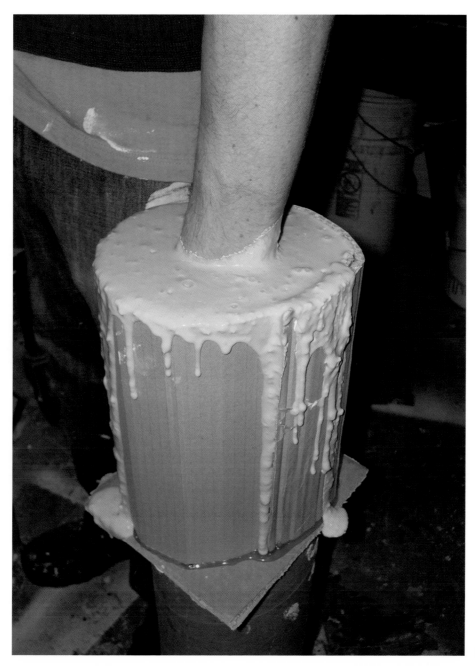

Body casting in process, 2006

Biography

Born October 1968, New York City
Lives and works in New York City

Education

1987–1991 Princeton University AB

Solo Exhibitions

2008
Lever House, New York

2007
Tracy Williams, Ltd., New York

2005
Tracy Williams, Ltd., New York
Art Positions, Art Basel / Miami Beach 2005, Tracy Williams, Ltd.

2004
Evergreene Gallery, Geneva

2003
Caren Golden Fine Art, New York

2001
Caren Golden Fine Art, New York
Greene Gallery, Geneva (catalogue)

1998
Greene Gallery, Geneva

Selected Group Exhibitions

2007
New Prints: Autumn 2007, International Print Center, New York

2006
Six Degrees of Separation, Stux Gallery, New York

2004
Me, Myself and I, Schmidt Center Gallery at FAU, Boca Raton, Florida (guest curators: Paul Laster and Renee Riccardo; catalogue)
Cindy Bernard, Richard Dupont, Judy Ledgerwood, Tracy Williams, Ltd., New York

2003
Druid: Wood as Superconductor, Space 101, Brooklyn

OnLine, Feigen Contemporary (online exhibition at www.feigencontemporary.com), New York (co-curated by Charlie Finch, George Negroponte and Robert Storr)
The Burnt Orange Heresy, Space 101, Brooklyn

2002
Bootleg Identity, Caren Golden Fine Art, New York
Proper Villains, Untitled (Space), New Haven (curated by David Hunt; catalogue)

2001
Colaboratory, Gale Gates Gallery, New York
Superimposition, Caren Golden Fine Art, New York (curated by David Hunt)

2000
DRAWN: An Exhibition of Selected Drawings, Barry Whistler Gallery, Dallas

1999
Gallery Artists, Galerie Andreas Binder, Munich
The Road Show, DFN Gallery, New York
A Room with a View, Sixth @ Prince Fine Art, New York

1998
Young American Artists, Part One, Galerie Andreas Binder, Munich
Der Goldene Schnitt, Projektraum im Kontorhaus (in cooperation with Galerie Andreas Binder), Berlin
Sculpture and Painting, Earl McGrath Gallery, New York
Misanthropes, 519 Broadway, New York

1997
Richard Dupont and Robert Medvedz, Woodward Gallery, New York
New York Artists, Ira Stehmann Kunst, Hamburg (catalogue)
New Art from New York, P inc. Studios, London

1996
Four Elements, Woodward Gallery, New York

1995
Tre Amerikaner, Stylt Gallery, Gotenburg
Semaphore, Bill Bace Gallery, New York (catalogue)

1994
Cristinerose Gallery, New York (catalogue)

Bibliography

2008

Richard Dupont: Terminal Stage, Edizioni Charta, Milan
"Naked Ambition," *Vogue*, May
Andrea Scott, "Goings On About Town: Richard Dupont," *The New Yorker*, April 14
Daniel Kunitz, "Richard Dupont's Naked Launch," *The Village Voice*, April 2
Ami Kealoha, "The Lever House Art Collection," *Cool Hunting Video* (coolhunting.com), April
Lindsay Pollak, "Nine Nudes," Bloomberg.com, March 28
Charlie Finch, "Starwalkers," *artnet.com*, March 18
Erica Orden, "One Man, Nine Times," *The New York Sun*, March 13
Ami Kealoha, "Episode 99: Richard Dupont," *Cool Hunting Video* (coolhunting.com), February
Faye Hirsch, "Print Fairs Thrive," *Art in America*, January, p. 35

2007

Charlie Finch, "Duped," *artnet.com*, November 16
Adam E. Mendelsohn, "Richard Dupont in Conversation with Adam E. Mendelsohn," *The Saatchi Gallery Daily Magazine*, August 10

2006

Stephanie Young, "Richard Dupont: We Can Build You," *Vellum*, fall/winter
Emily Hall, "Reviews: Richard Dupont," *Artforum*, January, pp. 224–225

2005

Seymour Chwast, "Goings on about Town: Richard Dupont," *The New Yorker*, October 17
"Sculpture and Digital Art Combine," *The Villager*, September 14–20, Volume 75, Number 17, p. 32
Walter Robinson, "Weekend Update," *artnet.com*, September 16
Daniel Kunitz, "Les Beaux Corps," *ArtReview*, September, pp. 92–95
James Westcott, "In the Studio: Richard Dupont," *artinfo.com*, September 1

2003

Barbara Pollack, "OnLine," *ARTnews*, September
Kim Levin, "Voice Choices: OnLine," *The Village Voice*, August 6–12
Nick Paumgarten, "Art and Entropy," *Modern Painters*, spring

Jessica Kerwin, "Body of Work," *W Magazine*, April
Ken Johnson, "Art in Review: Richard Dupont," *The New York Times*, February 7
Kim Levin, "Voice Choices: Richard Dupont," *The Village Voice*, February 5
Jessica Kerwin, "Body of Work," *Woman's Wear Daily*, January 21

2002

Crowd Magazine, Issue 2, summer
Kim Levin, "Voice Choices: Bootleg Identity," *The Village Voice*, July 23
Charlie Finch, "Life Is More Important Than Art," *artnet.com*, June/July

2001

Kevin Conley, "Goings On About Town: Art: Richard Dupont," *The New Yorker*, November 19
Merrily Kerr, "David Hunt's Superimposition," *NY Arts*, September
Kim Levin, "Voice Choices: "Superimposition," *The Village Voice*, July 31
Holland Cotter, "Art in Review: Superimposition, Caren Golden Fine Art," *The New York Times*, July 6

2000

Janet Kutner, "ArtsDay: Less and More," *The Dallas Morning News*, November 15
Mike Daniel, "'Drawn' at Barry Whistler," *The Dallas Morning News*, November 10

1999

"Mob Rules" (cover illustration), *NY Arts*
Norman Coady, "Misanthropes," *The Pony Express*, March

Public Collections

The Museum of Modern Art, New York
Whitney Museum of American Art, New York
The New York Public Library, New York

Authors Biographical Notes

Richard D. Marshall is an independent curator, art consultant and art historian based in New York. He was formerly a curator at the Whitney Museum of American Art, New York. He is curator of the Lever House Art Collection, New York.

David Hunt is a critic and curator living in Brooklyn, New York. His writing has appeared in numerous publications including *Frieze*, *Flash Art*, *Art/Text*, *BOMB* and *Newsweek*, as well as many exhibition catalogues.

Nick Paumgarten is a staff writer at *The New Yorker*. He lives in New York.

Concept
Devon Berger

Design
Daniela Meda, Gabriele Nason

Editorial Coordination
Filomena Moscatelli

Copyediting
Charles Gute

Copywriting and Press Office
Silvia Palombi Arte&Mostre, Milano

US Editorial Director
Francesca Sorace

Promotion and Web
Monica D'Emidio

Distribution
Antonia De Besi

Administration
Grazia De Giosa

Warehouse and Outlet
Roberto Curiale

Cover
Terminal Stage, Lever House, New York, 2008
Photo: Jesse David Harris

Edizioni Charta srl
Milano
via della Moscova, 27 - 20121
Tel. +39-026598098/026598200
Fax +39-026598577
e-mail: edcharta@tin.it

Charta Books Ltd.
New York City
Tribeca Office
Tel. +1-313-406-8468
e-mail: international@chartaartbooks.it

www.chartaartbooks.it

This publication follows the exhibition
Terminal Stage
at Lever House, 390 Park Avenue, New York
March 13 – May 3, 2008

*The artist would like to thank
the following people:*

Lauren Dupont
Aby Rosen
Alberto Mugrabi
Tracy Williams
Richard Marshall
Charlie Hines
Jeff Conaway
Carolina Nitsch
David Hunt
Nick Paumgarten
John Newsom
Jenny Grondin
Octavian Ureche
William Theodoracopulos
Jon Lash
John Rannou
Randy Carfagno
Jesse David Harris
Alva Karl
Todd Mueller
Konstantin Bojanov
Brian Rumbolo
Greg Burnet
Devon Berger

Jeff Conaway

Charlie Hines

To find out more about Charta,
and to learn about our most recent publications, visit

www.chartaartbooks.it

Printed in May 2008
by Leva Arti Grafiche, Sesto San Giovanni
for Edizioni Charta